CHICAGO CUBS
BASEBALL ON
CATALINA ISLAND

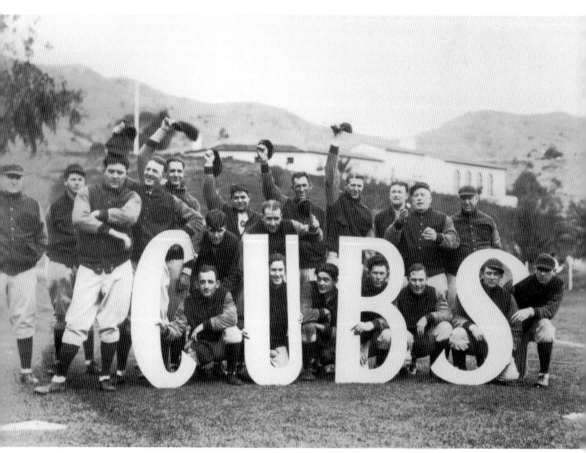

The 1930 Chicago Cubs arrived on Catalina Island with high hopes, since they had won the National League pennant just a few months earlier.

FRONT COVER: Veteran pitcher Bill Lee put a trio of Chicago Cubs rookies to work during the spring of 1936. Ken Weafer rows across Avalon Bay toward Catalina Island, while Gene Lillard and Johnny Hutchings offer moral support. Off past their starboard side is the fabled glass-bottom boat. Behind the old steamship pier stands the landmark casino.

COVER BACKGROUND: This image shows a few Cubbies leaping in the air.

BACK COVER: The team toyed with flight a few times as an alternative to the steamships, but the idea never caught on until the very end. In fact, the Pirates were planning on flying over for some games in 1946 but canceled because of too many worried Buccaneers. Yet the experiments generated a lot of initial excitement, in 1933, when the Cubs were among the first teams to fly.

Published by Arcadia Publishing
Charleston, South Carolina

Printed in the United States of America

Library of Congress Control Number: 2009934877

For all general information contact Arcadia Publishing at:
Telephone 843-853-2070
Fax 843-853-0044
E-mail sales@arcadiapublishing.com
For customer service and orders:
Toll-Free 1-888-313-2665

Visit us on the Internet at www.arcadiapublishing.com

This book is dedicated to The Boys of Spring—all those great-generation guys who played baseball on Catalina Island.

CHICAGO CUBS
BASEBALL ON
CATALINA ISLAND

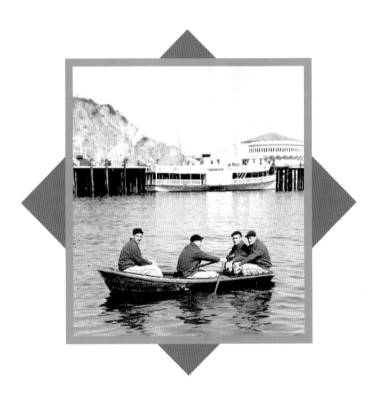

Jim Vitti

ARCADIA
PUBLISHING

CONTENTS

ACKNOWLEDGMENTS

A lot of people contributed to this book. In Avalon, Stacey Otte and Jeannine Pedersen of the Catalina Island Museum . . . Gail Hodge and Audry Paradisi of the Santa Catalina Island Company . . . and Lolo Saldaña made it magical. On the mainland, dozens of Catalina Cubs and family members generously shared stories and photos: Red Adams, Lee Anthony, Della Root Arnold, Don Carlsen, Lefty Carnett, Phil Cavarretta, Ed Chandler, Jack Cowell, Lonny Frey, Olinda and Pam Hacker, Buddy Hartnett, Sheila Hartnett Hornof, Randy Jackson, Yosh Kawano, Hub Kittle, Johnny Klippstein, Eddie Kowalski, Turk Lown, Gene Mauch, Carmen Mauro, Calvin Coolidge Julius Caesar Tuskahoma McLish, Lennie Merullo, Ox Miller, Charlie Owen, Bob Rush, Paul Schramka, Roy Smalley, Wayne Terwilliger, Corky Van Dyke, Sharon Epperly Vancil, and Gus Zernial.

Also, special thanks to Linda Hanrath of the William Wrigley Company, Nancy Reagan and her Chief of Staff Joanne Drake, Duke Blackwood of the Ronald Reagan Presidential Library, Parker Hamilton of the White House Press Office, Fay Gillis Wells, Bernard Taupin, Ernest Hemingway, the staff at the Chicago Public Library, and Jeff Ruetsche of Arcadia—a Hall of Fame caliber publisher/editor who's so good he needs a nickname.

All photographs are from the Bill Loughman Collection of the Catalina Island Museum and the Santa Catalina Island Company, unless otherwise credited. The baseball cards are thanks to Topps. For some Cubbie items, thanks to the Chicago National League Baseball Club, Inc. Other memorabilia, the Jim Allyn Collection—thanks to you and Rophe for always being there.

INTRODUCTION

From 1921 to 1951, the Chicago Cubs spent spring training time on Catalina Island just off the Southern California coast. During those years, the team won five National League pennants.

And during that time they also caught a lot of fish, danced with a lot of starlets, and pulled a lot of pranks. They hunted for wild boar, wrestled with pigs, galloped on horses, hiked mountain trails, and shagged a lot of pop-ups. They rode chugging locomotives and grand steamships to get to the island, playing cards, shooting dice, and telling tales that grew by the mile. They taught each other batting tips and how to get more movement on a fastball and, when veterans roomed with rookies, they explained the meaning of life.

These guys wore their heavy flannels in the sun and turned double plays and blasted long balls and settled into the shady green grass for a break, smelling the familiar fragrances of a freshly cut lawn and the unfamiliar sea-salt scent of the Pacific. They marched in parades when they arrived and played catch with the local kids while they were there and got a little teary-eyed when it was time to leave this home away from home that they had grown to love.

They'd rub saddle soap into their mitts, get liniment rubbed into their aching muscles (and Coca-Cola too, thanks to their quirky trainer), and they'd find out how easy it was to rub a cranky manager the wrong way. They'd sneak off to the watering hole to have a belt, and on a good day, belt a home run or two, right when the manager was watching.

The boys would eat too much and not sleep enough and sometimes field those grounders just right. Some would get brand-new nicknames, and others would discover they had somehow grown old during the off-season. A few were dazzled by all the new sights and sounds, some were so homesick they'd cry into their pillows at night—hoping that their roommate wouldn't hear.

They'd check out the island sights, like Bird Park and the tile works and the casino. They'd learn how to give interviews to the small army of reporters who had tagged along, then read the local paper (to see what they said) and listen to the radio for the latest news about the New Deal, the war in Europe, and what Babe Ruth was up to these days. They visited the golf course next to the ballpark, tried a little tennis here, a little ping-pong there. Plenty had never seen a palm tree before, or a beach, or a curveball that dropped, like that, out of nowhere.

Some marveled at their first stay at a grand hotel; others barely made an appearance in their room after dropping off their suitcase. The dapper lads chased the local skirts, the shy boys sat to themselves. And, unfortunately, until the very last years, they were all white.

The war got in the way, so spring camp got derailed to a cold snowy place for a few seasons in there, but the veterans who knew Catalina dreamed of a hasty return. And in February of 1946, glee filled the Avalon air once again. The ballplayers were back, able to return to the old tricks. The fellows wrote to the folks back on the farm and their buddies at the plant . . . and, of course, to the girl next door.

And right after being on this magical island, that faraway place, the tiny town at sea—off to Los Angeles, the rip-roaring big city, for stiff competition against other teams in genuine stadiums. Real stadiums. Big stadiums, with lots of cheering, jeering fans.

It was pretty crazy. A kid could be playing in high school with all the old familiar faces in familiar places one minute, and then he might soon be at a tiny wooden ballpark in Ottumwa or Texarkana or Rancho Cordova. All of a sudden, he could be standing on that same little 15-inch-high mound, but this time on an island, facing Phil Cavarretta, last year's National League MVP. And he was about 15 feet tall out there on Catalina, when everybody was watching, and that fastball that worked so well back home against Tommy and Pete and Charley was now lumbering toward the plate in slow motion—until Cavy hit it about as far away, and as fast, as Buck Rogers's spaceship.

But then in the locker room at the country club up the hill, after practice, Cavy might himself come over with a word of encouragement. On Catalina Island, in the springtime, there was always hope.

All this ended with a thud in 1952. Arizona instead? *Well,* thought the islanders, *they were away during the war. They'll be back soon enough.*

But they didn't come back. It was over. The Cubs became just a memory on Catalina—but what a memory. Here in these pages are the pictures and the stories. William Wrigley, who owned both the island and the Cubs, was shrewd enough to make sure plenty of publicity photographs appeared back in snowy Chicago, and they're preserved here, all these years later. Enjoy.

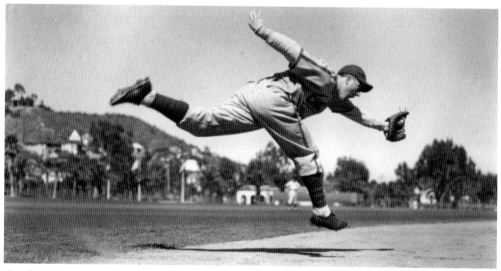

Catalina's mountains provide a stunning backdrop for the ballpark. Lennie Merullo, a rookie in 1941, leaps for a grounder—in near-perfect synchronization with the landscape behind.

BEFORE CATALINA

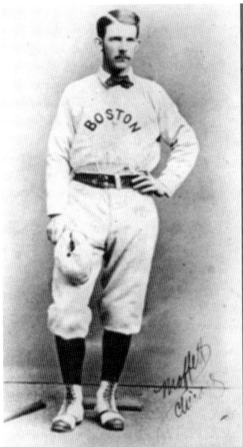

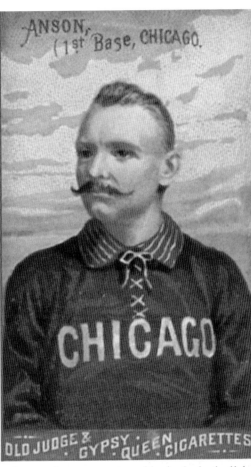

The earliest spring training sessions involved soaking in hot-water mineral baths (to boil off the booze consumed during the winter) rather than exercise. The first official Cub camp, in 1900, was held in Selma, Alabama. Over the next two decades, the team tried New Orleans; Vicksburg, Mississippi; Hot Springs, Arkansas; Tampa, Los Angeles, and Santa Monica among others. In 1917, they went to Pasadena—which led directly to their longtime love affair with Catalina Island. Before he started his sporting-goods business, Albert Spalding (left) started the National League. As player/manager for the 1876 Cubs (then called the White Stockings), his team won the first-ever National League pennant. They knew nothing of pitch counts; Al went 47-12 on the mound that season. Spalding recruited Cap Anson (right) to Chicago, and over the next 22 seasons Cap hit .300 or better 19 times. Anson went on to manage the team as they morphed into the Colts and the Orphans before finally becoming the Cubs. For a while, he was part owner.

"These are the saddest of possible words: Tinker to Evers to Chance." Such was the lament of New York Giants fan Franklin Pierce Adams in his 1910 poem, *Baseball's Sad Lexicon*. Joe Tinker, Johnny Evers, and Frank Chance were the mainstays of the Cubs infield during a decade when the team won four pennants—and two straight World Series crowns. Evers went on to be the first Cubs manager to take the team to Catalina Island, in 1921.

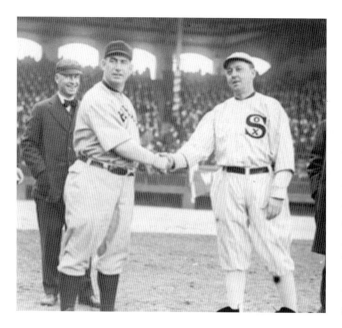

The Cubs and White Sox met in a crosstown World Series in 1906 (the Southsiders won), and the notion of an annual City Series was underway. By 1915, when Cubs skipper Roger Bresnahan made temporary peace with White Sox manager Pants Rowland, the frenzy was at full tilt. Rowland went on to scout for the Cubs and serve as president of the Los Angeles Angels before running the old Pacific Coast League (PCL) for years—leading the league's failed charge to achieve major-league status.

BEFORE CATALINA

William Wrigley Jr. started a soap business in 1891. Testing which premiums increased profits the most, he discovered that baking powder did it. He abandoned soap in favor of baking powder. From there, he discovered that chewing gum helped sell the most baking powder. Wrigley's cleaning products were tossed altogether, and the rest is history: within a few years, business had boomed sufficiently for him to buy the Chicago Cubs and Catalina Island among other interests.

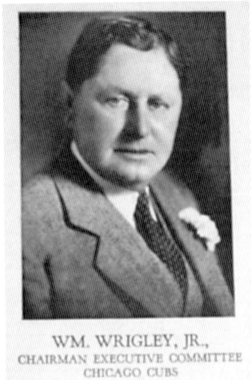

WM. WRIGLEY, JR.,
CHAIRMAN EXECUTIVE COMMITTEE
CHICAGO CUBS

The Wrigleys acquired a winter place in Pasadena, California, in part because the Cubs had been going through their spring drills there. While there, in 1919, he bought Catalina Island (sight unseen). Years later, the mansion became the headquarters for the annual Tournament of Roses festivities.

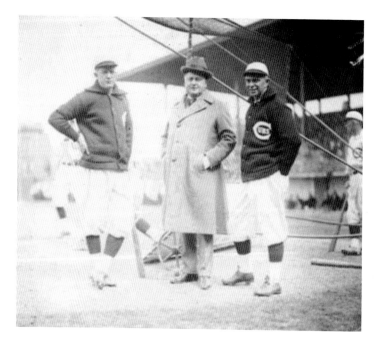

The Cubs acquired pitcher Grover Cleveland Alexander and catcher Bill Killefer from the Phillies in December 1917. This duo helped lead the resurgent Cubs to the 1918 pennant, but they lost the World Series to the Red Sox (thanks in part to Boston pitcher Babe Ruth's notching two wins). Wrigley, seen here with the pair, leveraged their stardom for publicity as he moved his team to the island.

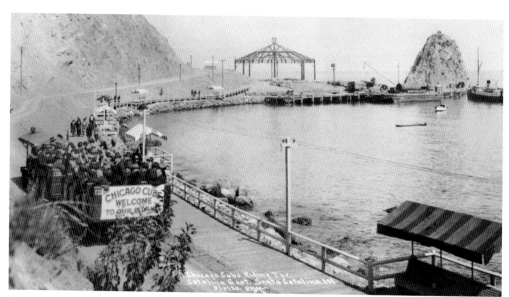

Bad weather, crumbling practice facilities, and grumpy hosts in Pasadena inspired Wrigley to wonder if his island might work for spring training. While in Southern California in 1920, he took the team over for a look—with typical Wrigleyesque fanfare. The locals rolled out the red carpet; the trip was a success, and his front office began planning the move for his team.

2

"No Trip Like This"

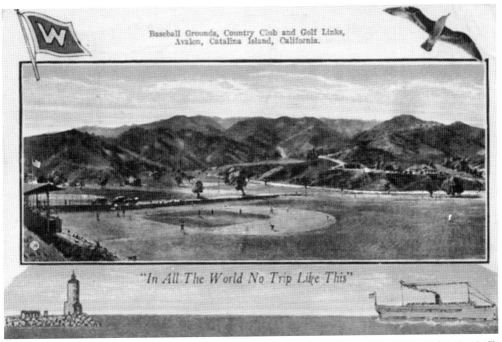

The Cubs went to Catalina every spring from 1921 to 1951, except during World War II (1943–1945), when they had to stay closer to home. The lengthy journey to and from the West Coast involved trains, steamships, occasionally a flight, and always merriment of all kinds. Wrigley's longtime slogan for Catalina was, "In All the World, No Trip Like This." This 1925 postcard showcases some of his ambitious projects: a new ballpark, a country club, a golf course, and the SS *Catalina* steaming into Avalon Harbor from the mainland.

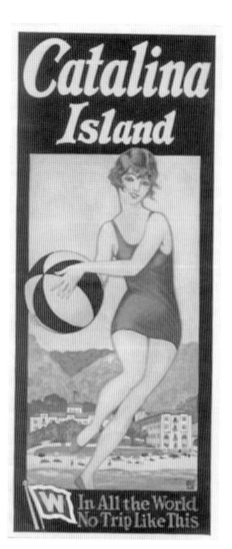

Travel brochures like this one, reflecting Roaring Twenties styles, spread the word in Chicago and beyond.

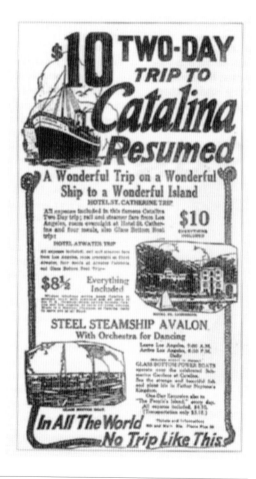

Whether or not William Wrigley invented the "all-inclusive vacation" format all those years ago, he certainly mastered it. This newspaper advertisement offers a complete vacation (rail transfers in Los Angeles, steamship passage, a hotel stay, meals, and even a glass-bottom boat ride) all for one tidy price.

"NO TRIP LIKE THIS"

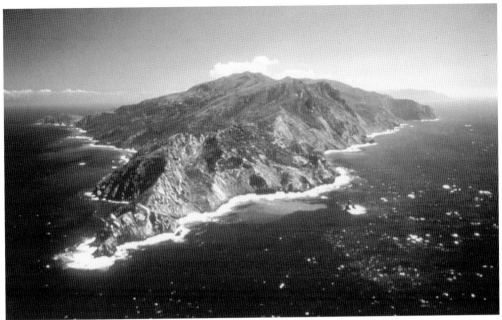

Although it is considered a small island, Santa Catalina Island looms large when approached by air or sea. It is a section of a submerged mountain range, more than 20 miles long, just over 20 miles off the California coast. The Wrigley family donated most of it to the Catalina Island Conservancy years ago, so the vast majority will be untouched except for a few hiking trails and campsites. This is the unpopulated West End.

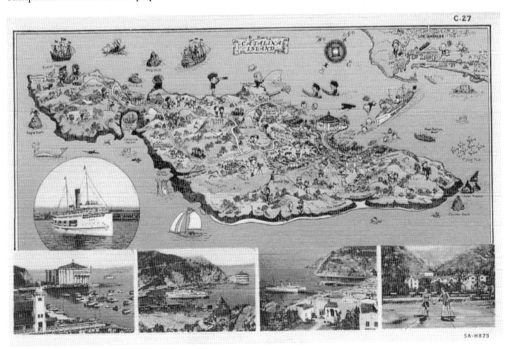

This vintage postcard provides an exaggerated view of what was where.

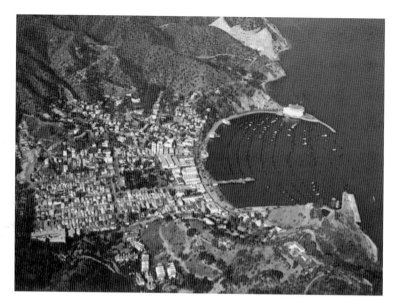

From high above, it is easy to see why Avalon Bay is an ideal environment for boats—and how the semi-level area fronting the bay was just right for a seaside California town. The landmark Catalina Casino, in the upper right, opened in 1929. At the time, it was the tallest building in Los Angeles County.

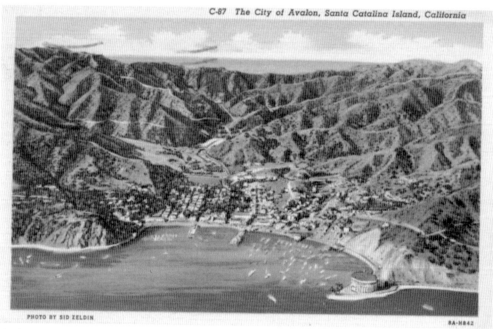

C-87 The City of Avalon, Santa Catalina Island, California

PHOTO BY SID ZELDIN 8A-H842

A closer view of the harbor shows the basic layout of the village. Avalon's population then, like now, was only a few thousand, and a person could walk across the entire town in less than 10 minutes. The ballpark, blending into the golf course, is near the center of this image—just above the neatly laid out little cottages.

"NO TRIP LIKE THIS"

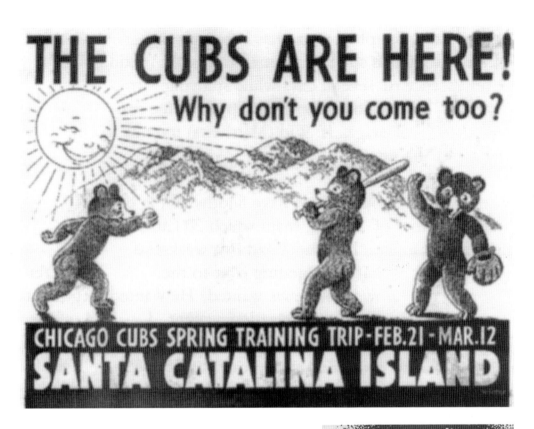

THE CUBS ARE HERE!
Why don't you come too?

CHICAGO CUBS SPRING TRAINING TRIP-FEB.21 - MAR.12
SANTA CATALINA ISLAND

Wrigley kept right on promoting, as evidenced by this 1937 newspaper advertisement.

Each spring, the team would distribute complete media guides with rosters, player biographies, itineraries, and other helpful information.

A little snow never hurt anybody, but Chicago gets a lot of snow, so the team had to head south for spring training. Before hitting the road in 1934, all-star shortstop Woody English tossed a few Wrigley Field snowballs, aided by trainer Andy Lotshaw. English liked the difference on Catalina, commenting, "We kind of fell in love with the beauty of it. Even [Rogers] Hornsby loved it, even though there weren't any racetracks."

The train trip from Chicago took three days. Then the team would spend about three weeks on Catalina before starting the long, slow journey home. They would take more than a month to meander back, stopping for plenty of exhibition games along the way—first in Los Angeles, against the Wrigley-owned PCL Angels at their Wrigley Field—before moving eastbound. Some seasons, they would take a spur north (as they did in 1931), playing against a few of the other PCL teams. The Pittsburgh Pirates trained in California for several years too, so those two would also face off on the northern leg. The Cubs would occasionally get an advance look at the City Series as well, when the White Sox trained in Pasadena.

Training Trip and Exhibition Games
Chicago Cubs, 1931

Feb. 14—Pitchers and catchers leave for Catalina Island, California, 12:30 P. M., Santa Fe Railroad.
Feb. 17—Arrive Avalon, Catalina Island, California.
Feb. 21—Second squad leaves for Catalina Island, California, Santa Fe Railroad.
Feb. 24—Arrive Avalon, Catalina Island, California.

Date	Opponent		Hotels
March 13	Cubs vs. Angels, at Los Angeles	BILTMORE	Mayfair
March 14	Cubs vs. Angels, at Los Angeles	"	Mayfair
March 15	Cubs vs. Angels, at Los Angeles	"	Mayfair
March 17	Cubs vs. Angels, at Los Angeles	"	Mayfair
March 18	Cubs vs. Angels, at Los Angeles	"	Mayfair
March 19	Cubs vs. Angels, at Los Angeles	"	Mayfair
March 20	Cubs vs. Pittsburgh, at San Francisco		Whitcomb
March 21	Cubs vs. Pittsburgh, at San Francisco		Whitcomb
March 22	Cubs vs. Pittsburgh, at San Francisco (2 games)		Whitcomb
March 23	Cubs vs. Oakland, at Oakland		Whitcomb
March 24	Cubs vs. San Francisco, at San Francisco		Whitcomb
March 25	Cubs vs. San Francisco, at San Francisco		Whitcomb
March 26	Cubs vs. San Francisco, at San Francisco		Whitcomb
March 27	Cubs vs. San Francisco, at San Francisco		Whitcomb
March 28	Cubs vs. San Francisco (Oakland at Fresno—second team), at San Francisco		Whitcomb
March 29	Cubs vs. San Francisco (2 games)—Oakland at Fresno—second team), at San Francisco		Whitcomb
March 30	Cubs vs. Pittsburgh, at Los Angeles	BILTMORE	Mayfair
March 31	Cubs vs. Pittsburgh, at Los Angeles	"	Mayfair
April 1	Cubs vs. Pittsburgh, at Los Angeles	"	Mayfair
April 2	Cubs vs. Angels, at Los Angeles	"	Mayfair
April 3	Cubs vs. Angels, at Los Angeles	"	Mayfair
April 4	Cubs vs. Hollywood, at Los Angeles	"	Mayfair
April 5	Cubs vs. Hollywood, at Los Angeles	"	Mayfair
April 7	Cubs vs. Fort Worth, at Fort Worth		Texas
April 8	Cubs vs. Fort Worth, at Fort Worth		Texas
April 9	Cubs vs. Kansas City, at Kansas City		President
April 10	Cubs vs. Kansas City, at Kansas City		President
April 11	Cubs vs. Kansas City, at Kansas City		President
April 12	Cubs vs. Kansas City, at Kansas City		President
April 14	Cubs open season at Chicago.		

NEELY PRINTING CO., CHICAGO, ILL.

"NO TRIP LIKE THIS"

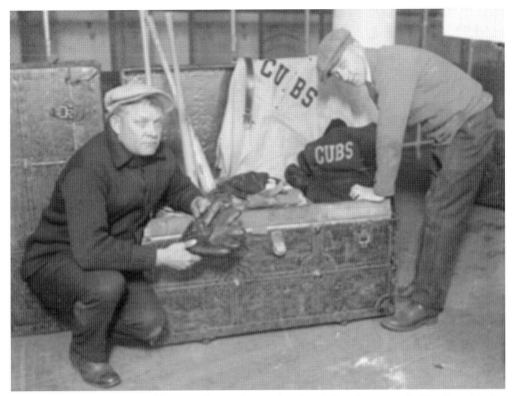

Grounds superintendent Bobby Dorr (not to be confused with Red Sox great Bobby Doerr) helps Andy Lotshaw pack the gloves for the 1926 trip. Dorr lived in an apartment at the ballpark near the left-field gate. The dwelling is still there, but these days it is used for storage by the food services group.

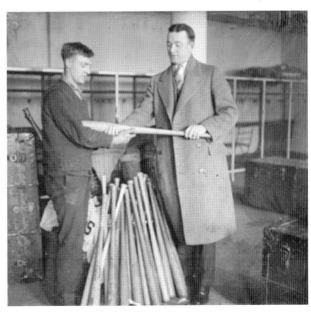

After the gloves came the lumber. Here catcher "Gabby" Hartnett (right) inspects the merchandise, aided by Harry Hazelwood.

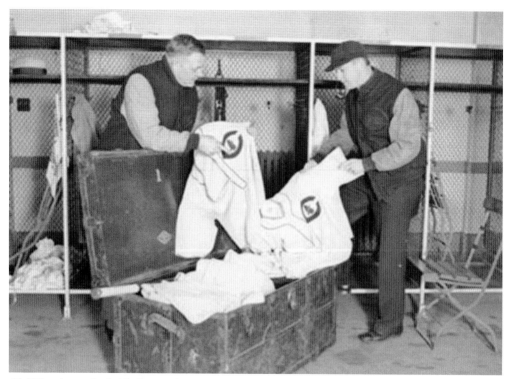

Cliff Heathcote (right) helps Andy Lotshaw with loading the uniforms. Heathcote and Max Flack are the only two ballplayers ever traded between games of a doubleheader. It happened in 1922, at Wrigley Field, as the Cubs faced the Cardinals. So naturally, Cliff had to find his new Cubbie jersey that afternoon—an odd moment celebrated by the clever cameraman.

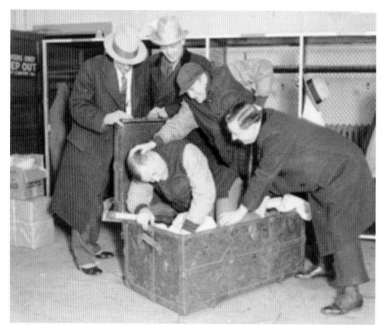

Got everything? The photo opportunity went mad when pitchers Guy Bush, Sheriff Blake, Heathcote, and team traveling secretary Bob Lewis assisted Lotshaw into the trunk.

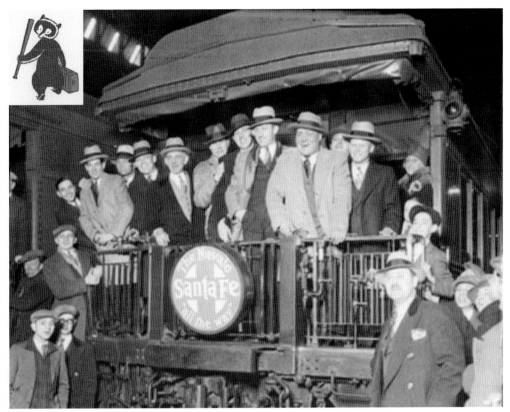

Hundreds of faithful fans would brave February windchills to see their team board the Santa Fe at the Dearborn Street Station each year. Aboard the train, card playing and dominoes were favorite choices to pass the time, except maybe for planting unusual items in rookie sleeping berths (such as iron train wheels, which required several veterans to lift into place, and crates full of garlic after the train made its way into California farming towns). Charlie Grimm called Woody English "a genius for pranks." One of his specialties made the hotfoot look like child's play: he would light a newspaper while someone was reading it. "His escape is made during the smoldering stage," explained *Des Moines Dispatch* columnist Ronald "Dutch" Reagan in 1937, "and he is innocently dozing when the reader finds himself possessed of a flaming torch." The inset seen here shows the back of the 1940 media guide. With everything packed away, the Cubbies could board their westbound train.

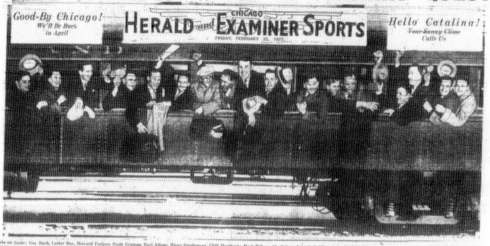

CUBS CATALINA BOUND IN PENNANT QUEST

Good-By Chicago! We'll Be Back in April

HERALD and EXAMINER SPORTS

CHICAGO FRIDAY, FEBRUARY 25, 1927.

Hello Catalina! Your Sunny Clime Calls Us

Cubs on train: Guy Bush, Luther Roy, Howard Freigau, Hack Grampp, Earl Adams, Riggs Stephenson, Cliff Heathcote, Hack Wilson, Mc Tshee, Johnie Hellfbuzel, Art Quelster, E. Hower, A. LaDuhit, Elbert, Hartnell, Webb and Sober

| Southey tell me | SOUTHERN SUNSHINE LURING 600 MAJOR LEAGUERS TO CAMP | Ruppert Is Mum on Babe Ruth's Wage Ultimatum | CHICAGO PLANS $20,000 OPEN DURING 1928 | Tex' Ban May Keep Jack From Ring, Fans Say | 24 SAY AU REVOIR TO CHICAGO UNTIL OPENER APRIL 12 |

CIENF·EGOS

ANTONIO Alcalde

The press coverage was enormous; did revenues from chewing gum advertisements have an impact? By 1927, the departure was the talk of the town.

Pitcher Al Epperly played on some other islands—like Cuba, where he suited up for the fabled Cienfuegos Elefantes. Yet he almost didn't make it to Catalina in the spring of 1937. Pard stepped off the locomotive in Ogden, Utah, to stretch his legs, but the train was running a little late, so the engineer didn't stay as long as scheduled and left without him. Fortunately, another train came along just 10 minutes later, and he caught up with his mates in Salt Lake City.

Amtrak is no match for the wood-brass-upholstered Pullman lounge cars. Charlie Grimm brought along his banjo and crooned with Cliff Heathcote in 1928. The practice worked, as a few springs later Reagan wrote in his column that Grimm was "the best banjo player in baseball."

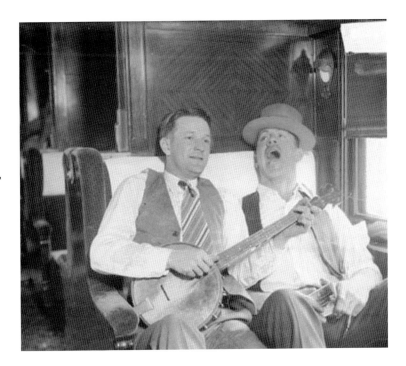

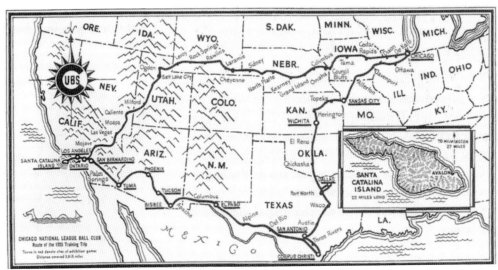

The northern route, although colder, was quicker. Yet after the kinks were out, the warmer southern lines made more sense as the boys could play exhibition games on the slower path back to Chicago. This was the route the Cubs took in 1939.

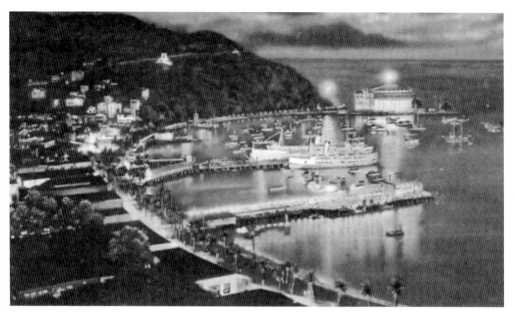

Avalon Bay looks pretty much as it did in the glory days. The biggest difference is the absence of the steamship pier, which once dominated the center. After three days on a train, a mere three-hour boat ride seemed a welcome notion.

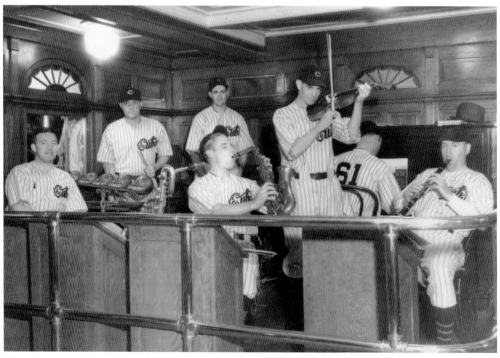

The ships were large enough to include a dance floor, so the big bands of the day entertained during the trip. In 1934, some of the ballplayers took over the bandstand on the SS *Avalon*, but alas, no audio recordings survived.

Kirby Higbe, who never met a photo opportunity he didn't like, wasn't satisfied with taking over anything as mundane as a mere bandstand. Along with his wife, Hig took command of the entire vessel.

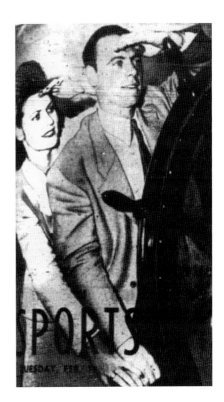

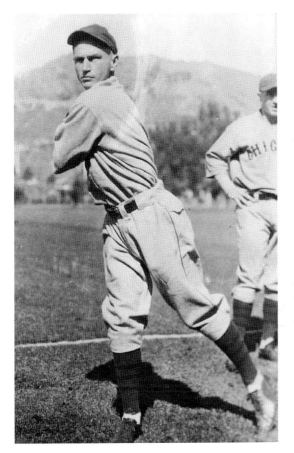

Greenhorn Percy Jones was dispatched below deck to find the bowling alley—a common rookie ruse. "I looked all over the boat and finally wound up in the engine room," he confessed. "By the time I tried a few other places, the whistle blew, and I figured I'd go upstairs to see what it was all about." He recovered nicely, earning a spot in the 1926 starting rotation.

Charlie Root took his family on a cruise to Australia before the 1933 camp. They returned to Los Angeles just in time to transfer lines to Catalina. He took Dorothy and the kids (Della and Charlie Jr.) to Avalon for 14 seasons. Schoolteachers back home in Chicago complained, but Della recalls, her mother would reply to them, "Would *you* rather go to school, or to Catalina?"

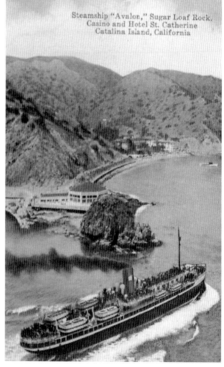

Steamship "Avalon," Sugar Loaf Rock, Casino and Hotel St. Catherine Catalina Island, California

The SS *Avalon* ferried the team during their first and final sailing seasons (1921 and 1950—they went by air in 1951). She was later converted to a barge, which sank off Palos Verdes during a 1960s squall and is today a popular dive site.

"NO TRIP LIKE THIS"

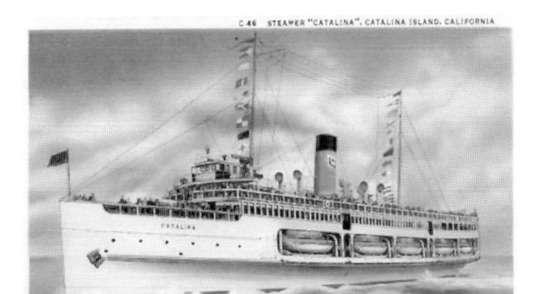

The SS *Catalina* was the Cubs' liner of choice most seasons—where most revelry, pranks, and seasickness occurred. (Trainer Andy Lotshaw helped out seasick rookies by distributing crisp bacon during the voyage.) But only the ghosts remain now; after a grand past, the Catalina has been listing in Ensenada Harbor (about 200 miles south, in Mexico) for over 40 years. Despite attempts to have the ship restored, authorities there recently okayed a plan to have her dismantled for scrap.

The team toyed with flight a few times as an alternative to the steamships, but the idea never caught on until the very end. In fact, the Pirates were planning on flying over for some games in 1946 but canceled because of too many worried Buccaneers. Yet the experiments generated a lot of initial excitement in Avalon, in 1933, when the Cubs were among the first teams to fly.

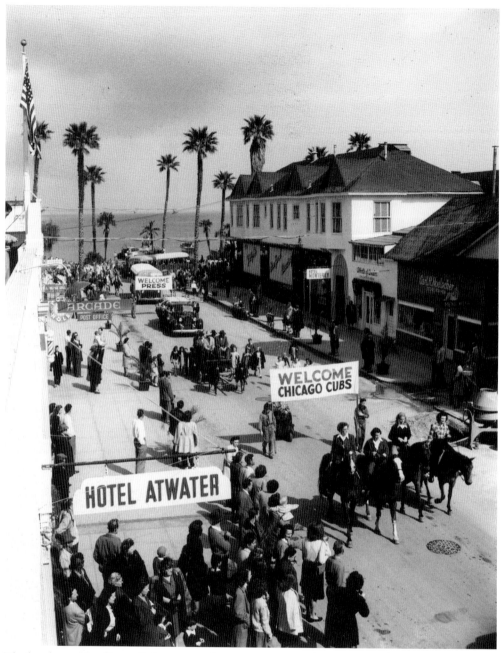

The locals would pull out all the stops and come out to greet their returning heroes with speeches, a parade, and music. This was the 1947 celebration.

After the big celebration, the boys loaded onto trucks en route to their digs in 1937.

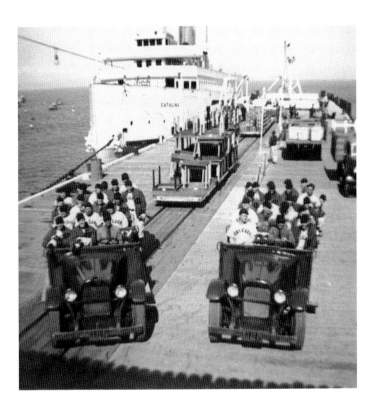

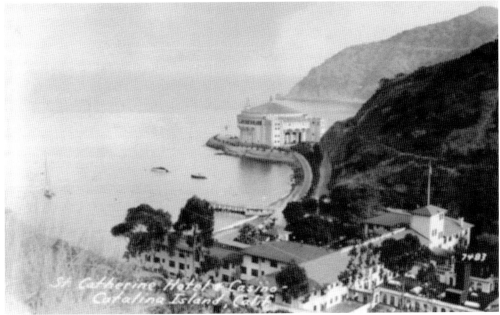

The team usually stayed at the posh Hotel St. Catherine, which hosted movie stars, big bands, and all sorts of other celebrities. The resort occupied Descanso Cove, a short walk west of the village, but it's long gone. The army took the hotel over for barracks during World War II, and then the property was lazily converted to apartments. The grand structure was demolished in 1966.

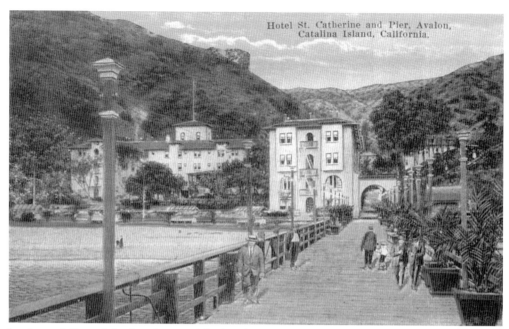

Hotel St. Catherine and Pier, Avalon, Catalina Island, California.

Look carefully and the foundation of the hotel pier can still be seen. One of the journalists who covered the Cubs in 1937—radioman Dutch Reagan of WHO in Des Moines—experienced a reality check there on his first trip to the West Coast. "The day I arrived," he recalled, "was a record-breaking 82 degrees. I, of course, assumed it was just standard. I wasn't in the hotel 10 minutes before, clad in trunks, I was running out to the end of the pier. I dived into the coldest water that was still liquid I've ever known. Awestruck natives watched me as if I were from outer space, and I rewarded them. I swear I didn't swim—I walked ashore on top of the waves."

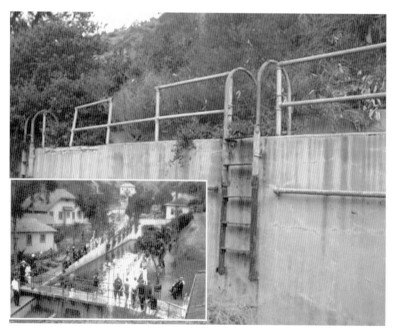

While the hotel is gone, the pool is still there (but tough to reach) if one feels like stepping back in time. The water was slightly warmer than the ocean Reagan encountered at the hotel's unusually shaped pool (inset), known as the plunge. It was built in a narrow gorge to the side of the main building.

"NO TRIP LIKE THIS"

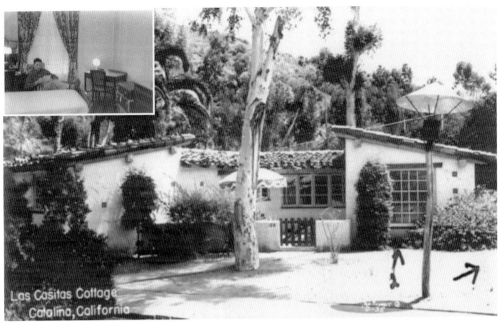

Just past the right-field fence, Las Casitas offered bungalow appeal—usually for married players, but some of the single guys stayed there too. Don Carlsen shared this end unit with Roy Smalley in 1948, when both came out early to get in shape. After the war, the Cubs stayed at other locations, including the Hotel Atwater (inset), which is still in business. Warren Hacker shared a room with Corky Van Dyke, seen here reading the mail from back home in Illinois. (Courtesy of Olinda Hacker.)

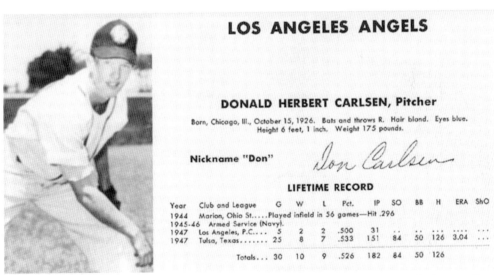

LOS ANGELES ANGELS

DONALD HERBERT CARLSEN, Pitcher

Born, Chicago, Ill., October 15, 1926. Bats and throws R. Hair blond. Eyes blue.
Height 6 feet, 1 inch. Weight 175 pounds.

Nickname "Don"

Don Carlsen

LIFETIME RECORD

Year	Club and League	G	W	L	Pct.	IP	SO	BB	H	ERA	ShO
1944	Marion, Ohio St.....Played infield in 56 games—Hit .296										
1945-46	Armed Service (Navy).										
1947	Los Angeles, P.C....	5	2	2	.500	31
1947	Tulsa, Texas........	25	8	7	.533	151	84	50	126	3.04	...
	Totals...	30	10	9	.526	182	84	50	126		

Carlsen and Smalley divided labor ("He'd cook, and I'd do the housekeeping," Carlsen said), so they would have some spare time. "We met a couple of local girls," Smalley added, but "there wasn't a lot to do. Feminine companionship was nice to have after being in the mountains with pigs and goats and buffaloes!"

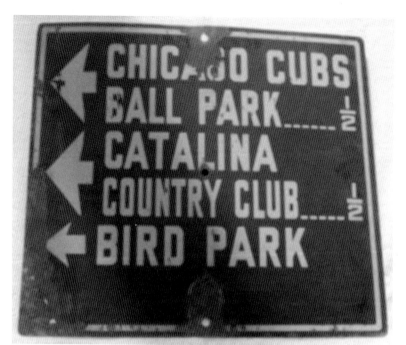

This large sign gave tourists the heads-up from waterfront Crescent Avenue as soon as they stepped off the steamship pier.

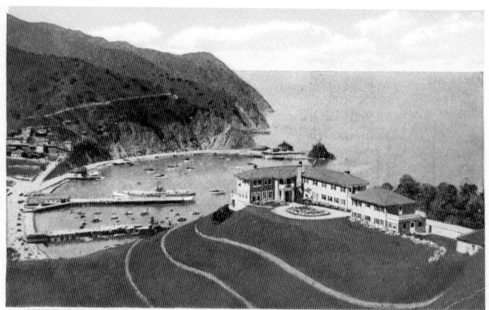

RESIDENCE OF WM. WRIGLEY, JR., CATALINA ISLAND, CALIF.

The family's island mansion, Mount Ada, was named after Wrigley's wife. On days he couldn't get to the field for practice, he would peer down from a telescope. If he spotted a player slacking off, he would send an "invitation" to come see him. One trip up the steep mountainside, along with the humiliation, usually cured a slothful athlete.

"NO TRIP LIKE THIS"

Once the tourists made their way to the "outskirts" of town (about three blocks) up Avalon Canyon Road, this smaller sign helped direct them. This vacationing fan stopped in the shade of the palm tree in 1925 before completing the journey to the grandstand.

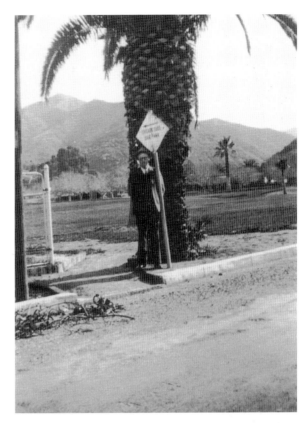

Years later, the Santa Catalina Island Company put a large stone marker in the same spot. Three plaques were placed there: one had been at Wrigley Field in Los Angeles, commemorating World War I veterans; another honored the Wrigley family; and the third commemorated the Cubs' 1921–1951 stay on the island.

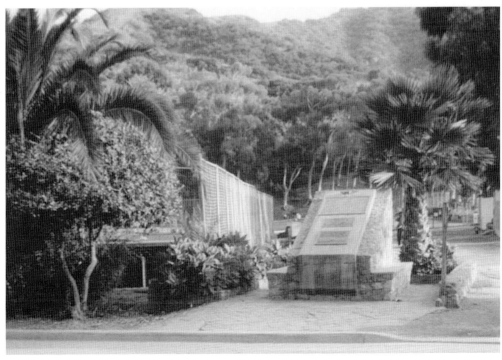

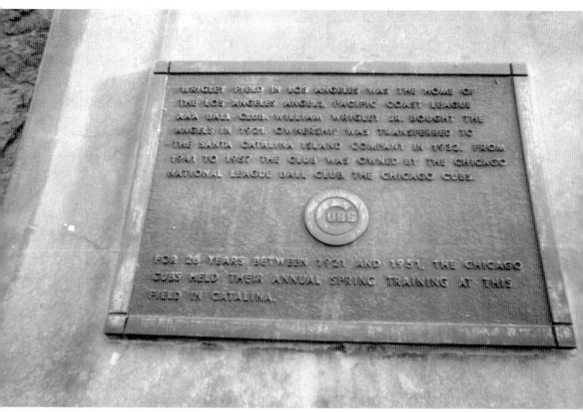

The Cubs marker included the familiar team logo and read, in part, "For 26 years, from 1921 to 1951, the Chicago Cubs held their annual spring training at this field in Catalina." Unfortunately, when the new city hall and fire station were built (just beyond the old left-field wall) a few years back, the marker was "temporarily" removed—and hasn't been put back in place yet. The field is still tucked behind the new buildings, used by the high school's sports teams.

3

PRACTICE

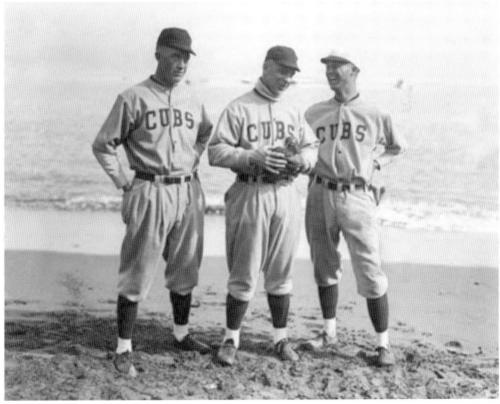

Once they made it across the West on the train (about 2,000 miles, depending on the route) and the San Pedro Channel on the boat (about 25 more), it was finally time for the Cubs to stretch their legs and go to work. Different managers used different methods over the years, but when it was time to leave, the boys were generally in pretty good shape. At first, the team did some workouts on the sandy beach—a natural idea. But cleats weren't designed for wet sand, which got into everything and foiled footing. Soon enough, the team moved up the hill to a level field. In this 1922 shot, Grover Cleveland Alexander, manager Bill Killefer, and Speed Martin chat as the waves crash behind them.

"Reindeer" Bill Killefer was the second Cubs manager to lead his troupe to sea. Behind him, on the hill, is Lookout Cottage (better known as Holly Hill House), a local landmark still visible from the village today. In all, Bill's career spanned six decades (1909–1958) as a player, coach, manager, and scout. In the inset, the Cubs knock out the kinks with bending and stretching on the sand. The large adobe building at the upper left was novelist Zane Grey's house, which is now used as a bed and breakfast.

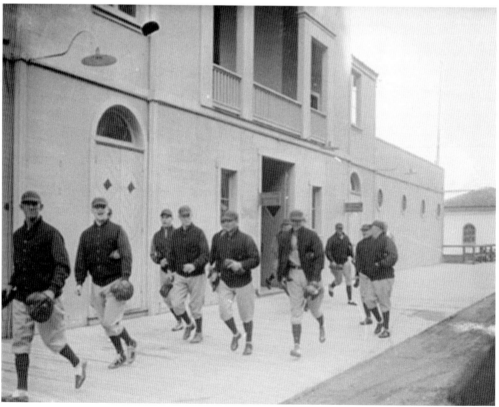

At first, the locker room occupied the old bathhouse right on the water, which was a bit inconvenient to trudge so far to the field after they had suited up. As late as 1928, the team was still getting some action at the beach, yet by then it was mostly mugging for the photographers.

PRACTICE

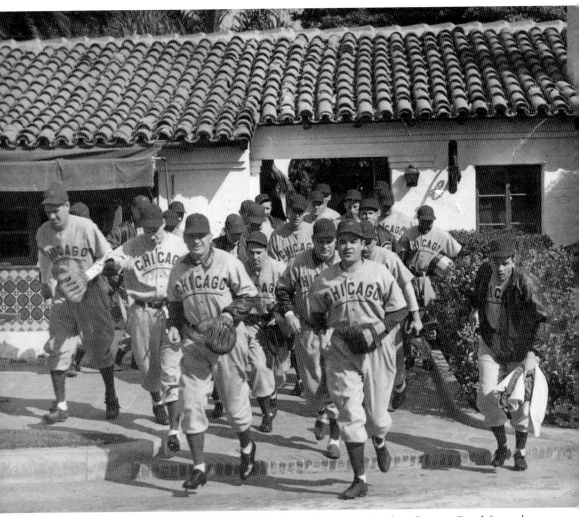

By 1928, the country club was completed. It was right across Avalon Canyon Road from the ballpark—an easy jog down and a tougher walk back up. Here are the Cubs emerging from the clubhouse in 1946 on their way to practice.

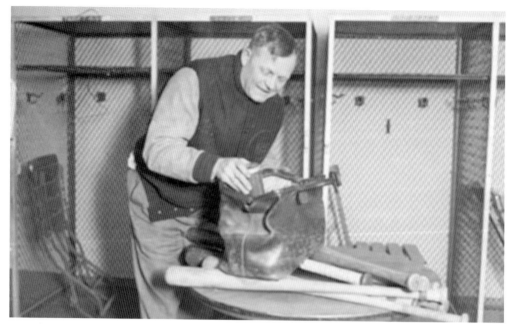

Everybody called Andy Lotshaw "Doc," but the mischievous team trainer learned his tricks on the fly rather than at medical school. (He was also the Chicago Bears trainer in the brand-new National Football League.) Players never knew what he'd pull out of his big black bag of tricks; he was known for using Coca-Cola as a rubdown tonic.

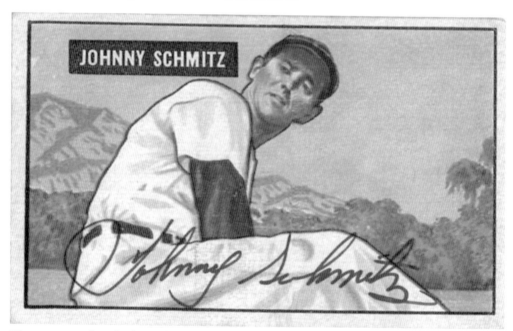

The setting was breathtaking, this ballpark in a little canyon surrounded by rugged mountains. The background on several 1951 Bowman baseball cards clearly reveals the images came from Catalina rather than Chicago; like the sunlight beginning to set on the bluffs behind Johnny Schmitz.

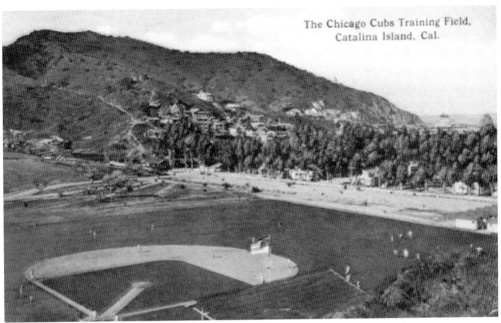

The Chicago Cubs Training Field,
Catalina Island, Cal.

Of course, the field was still just a short walk from the ocean, which can be seen in the upper right of this early postcard peeking down over the top of the tiny green grandstand. The old cracker-box ballpark on the island was one of three named Wrigley Field. The Cubs' home in Chicago is the most famous, of course, but William Wrigley also owned the Los Angeles Angels of the old Pacific Coast League, and their park was the first to bear the Wrigley name.

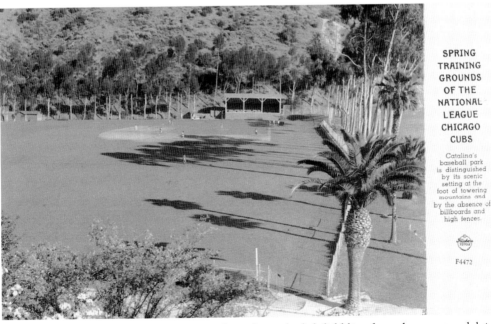

SPRING
TRAINING
GROUNDS
OF THE
NATIONAL
LEAGUE
CHICAGO
CUBS

Catalina's
baseball park
is distinguished
by its scenic
setting at the
foot of towering
mountains and
by the absence of
billboards and
high fences.

F4472

The field didn't change over the years. Looking down the left-field line from the country club in 1950, everything appeared the same as it had for the previous three decades.

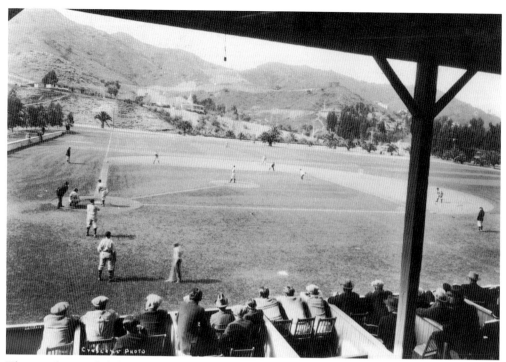

The stands provided shaded, old-fashioned wooden bleachers for a few hundred fans and a great view just behind home plate on the first-base side.

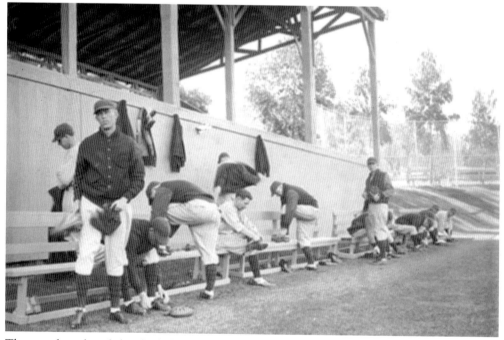

The grandstand roof also shaded the "dugout"—the benches for the players. Note the hooks for sweaters and jackets right below the front row of the stands that are within easy reach of the fans.

PRACTICE

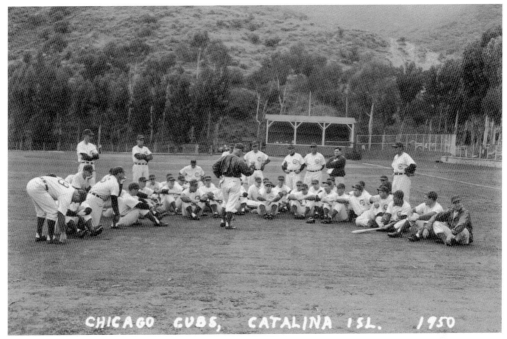

In this photograph, manager Frankie Frisch motivates the boys. From field level, it is clear the grandstand stood at the base of a steep hill. It also straddled a narrow drainage ditch.

Today part of the grandstand's foundation remains. It isn't the kind of thing people would likely notice unless they knew the rich history of the spot.

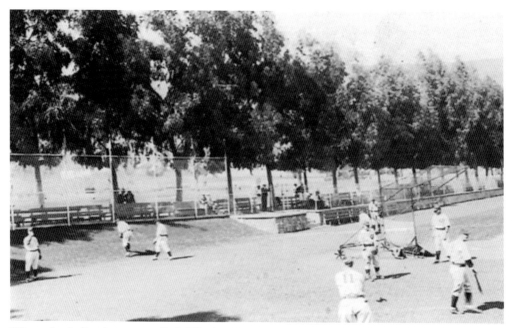

When the ballpark was installed, Wrigley's engineers wisely included a neat row of eucalyptus trees down the third-base line to offer shade, a nice frame to the ballpark, and a barrier from wayward golf balls (the course is immediately next to the diamond). Martha Hartnett, Gabby's bride, snapped this image in 1939.

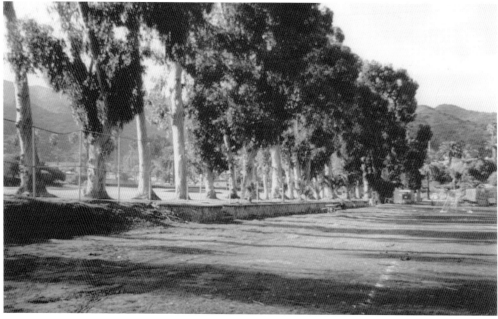

Seventy years later, that particular view remains virtually unchanged.

PRACTICE

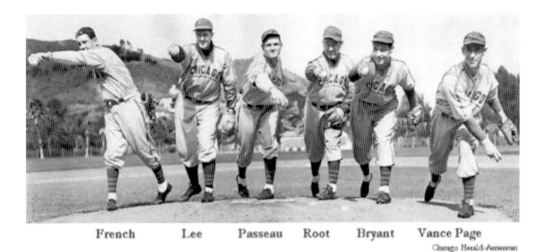

French Lee Passeau Root Bryant Vance Page

Chicago Herald-American

The Cubs pitching staff was strong and deep in 1940: Larry French averaged 15 wins a year over six Cub seasons, Big Bill Lee went 22-9 in 1938, Claude Passeau would toss a one-hitter in the 1945 World Series, Charlie Root is the all-time Cubs leader in wins (201 in all—34 more than Fergie Jenkins), Clay Bryant led the league in strikeouts in 1938, and Vance Page . . . well, they had high hopes for Vance Page in 1940.

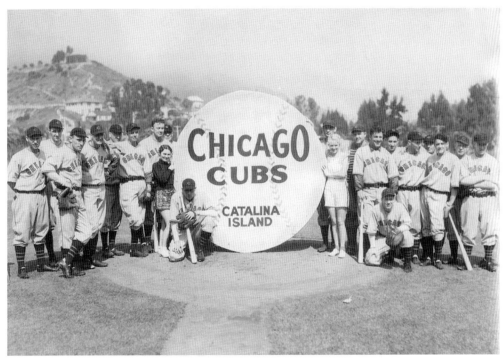

The Cubs used the field and its surroundings as an attractive setting for team pictures. In 1934, as in other years, some of the locals made the club a nice sign—and a few managed to sneak into the picture as well.

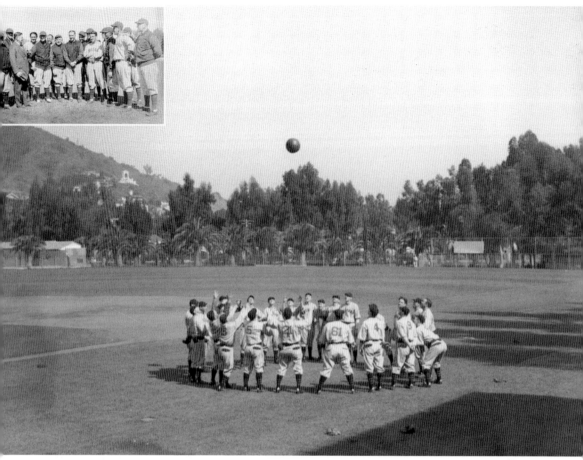

In the 1930s, the medicine ball was a training staple. These large leather globes weighed 25 pounds or more; one wonders how the one pictured here got that high into the air. William Wrigley was a hands-on owner, making the trip each spring and spending plenty of time on the field. In 1928, he helped manager Joe McCarthy inspect the troops (inset).

OPPOSITE PAGE: Andy Lotshaw leads the 1928 team in stretching. The teenager helping in front is 14-year-old Bill Veeck, whose dad was president and treasurer of the Cubs at the time. Veeck later planted the ivy on Wrigley Field's walls and earned a reputation as the game's most brilliant promoter. He sent a midget to pinch hit for the St. Louis Browns, integrated the American League with the Cleveland Indians, and introduced shorts as major-league attire with the Chicago White Sox. His ChiSox also had an exploding scoreboard and Disco Demolition Night that resulted in a riot.

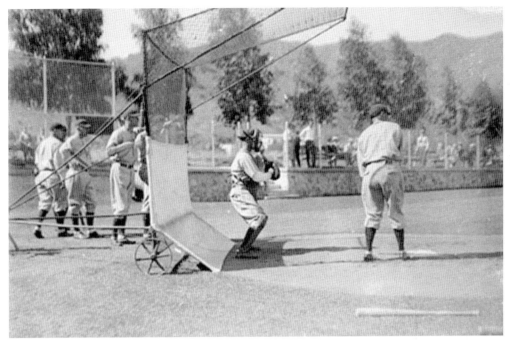

Portable batting cages are common now, but they weren't always. In fact, this 1928 makeshift model was a pioneering effort, necessary because of the close proximity of the spectators. Notice there is no number on the batter's jersey; the Cubs' uniforms weren't numbered until 1932.

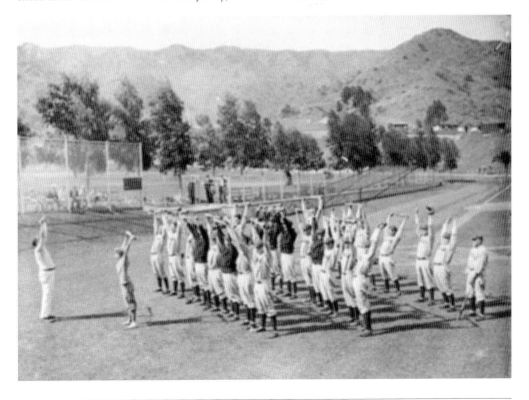

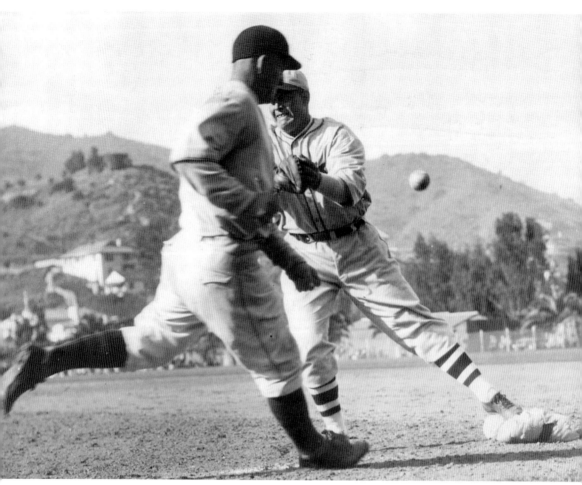

The New York Giants came over to play in 1932 and 1933. Fans spilled over the edges of the stands and lined all around the field to watch genuine major-league action on the island. Here Cubbie outfielder Riggs Stephenson digs to leg out an infield hit, but the errant Giant throw had already eluded Sam Leslie's grasp.

After the Chicago Cubs left the island, the semi-professional Catalina Cubs (sometimes Angels) remained, sponsored by the Wrigleys. They played against squads from Standard Oil, Paramount Pictures, and others. This 1930 Catalina Cubs scorecard came complete with plenty of advertisements from local sponsors.

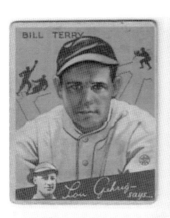

BILL TERRY

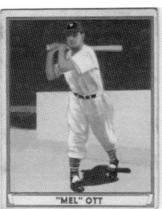

"MEL" OTT

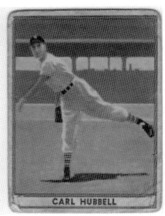

CARL HUBBELL

In a 1932 game, in this tiny ballpark on this tiny island, fans watched 12 future Hall-of-Famers take the field at once. Five of the 1932 Cubs and seven of the 1932 Giants made their way to Cooperstown: manager John McGraw, Bill Terry, Mel Ott, Carl Hubbell, Freddie Lindstrom, Waite Hoyt, and Travis Jackson for New York; Gabby Hartnett, Billy Herman, Kiki Cuyler, Rogers Hornsby, and Burleigh Grimes for Chicago. Dolf Luque of the Giants is in the Cuban Hall of Fame, and two Cubs—Charlie Grimm and Charlie Root—ought to be in Cooperstown. There was almost another Hall-of-Famer on the field that day, but by the end of the 1931 season, the Cubs had tired of center fielder Hack Wilson's alcohol-fueled antics and traded him away.

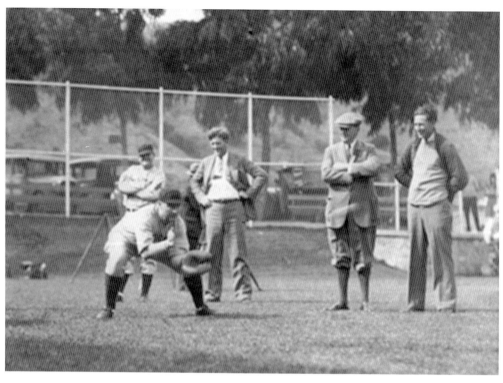

William Wrigley, donning the stylish knickers of the day, supervises catcher Johnny Schulte. One time Charlie Root found Schulte bellowing curses out the hotel window at some roofers. The catcher explained, "They're the guys who yell at me when I'm working!"

P. K. Wrigley took over the reins after his father died in 1932. Here he attempts to engage Charlie Grimm in a serious discussion—without much success.

PRACTICE

Shown here surrounded by sportswriters, Charlie Grimm managed the press as well as he did his players. Famous for one-liners, Grimm was a key element in the Wrigley public-relations machine during his 12 seasons as a player, his 14 years as Cubs skipper (which included four pennants), and many more as an unofficial Cubs ambassador to the world. Upon Grimm's request, after his death in 1983, his ashes were scattered over Wrigley Field.

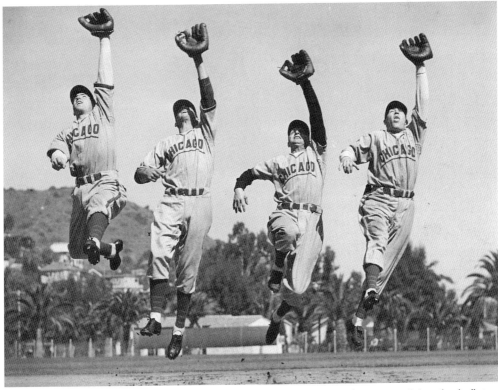

The sportswriters were accompanied by photographers galore, who snapped four high-flying infielders in 1940. From left to right, Lennie Merullo, Bobby Sturgeon, Billy Rogell, and Bobby Mattick reach for the gulls.

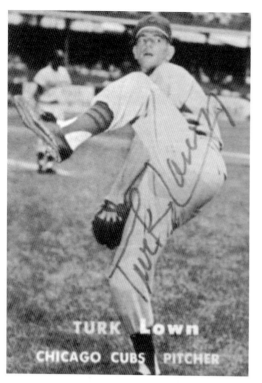

The practice field was the place to work out the mechanics of movement. Turk Lown developed an unorthodox pitching style, but it worked. During his 11 big-league seasons, he was one of the top closers in the game—before the game really had closers. His career highlights included three strong appearances in the 1959 World Series for that other Chicago team.

Different managers used different training methods. In 1950, Frankie Frisch felt climbing mountains, long runs, and short sprints would do the trick. They didn't, as the beleaguered wind sprinters here finished seventh in the eight-team National League.

TOO MUCH SPARE TIME

Practice usually only took about four hours each day. After that, the ballplayers could explore all the typical tourist attractions on Wrigley's playground. With camp completely surrounded by water, it was easy to be lured to aquatic distraction. In this 1934 image, Dutch Seebold and Bud Tinning have snuck off for a "catching strategy session," aided by a loyal local dog who keeps a lookout for giant sea bass.

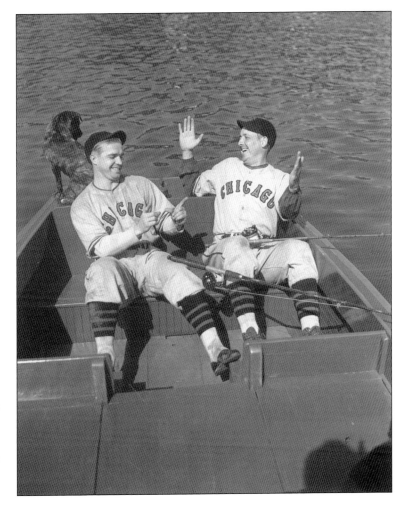

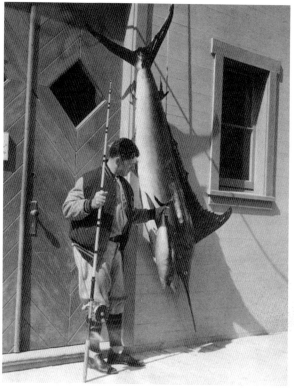

In this 1928 photograph, it appears the guys are either getting back in shape with a rowing drill, preparing to evacuate the island in case of an emergency, or simply goofing off for the cameras. Behind their landing site is the old long-gone steamship pier, where the real landings occurred. Behind that stands the Sugarloaf Casino (later dismantled, moved, and reassembled to become the focal point of Bird Park).

Charlie Grimm checks out the catch of the day on the Pleasure Pier (Green Pier), which is still used in Avalon Bay today.

TOO MUCH SPARE TIME

Veteran backstop Gabby Hartnett (second from right) teaches rookies how to catch the (nonexistent) April Fish. Initiation pranks abounded on the island, often related to marine life—such as first-timers finding large (and still living) sea creatures in their lockers or smaller surprises in their gloves.

Rookie hopefuls Duncan Grant (left) and Al Epperly have hooked quite a catch here in 1937. Epperly made the big squad the next season and chalked up a 2-0 record, but Grant—like so many other fresh-faced farm boys with big dreams—never reached the Show.

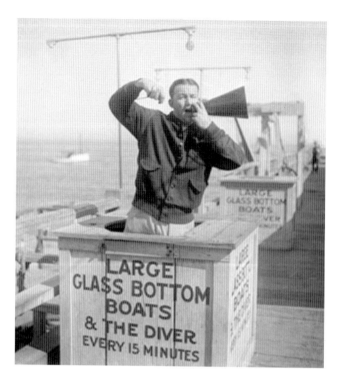

Gabby Hartnett took it upon himself to help the Wrigley glass bottom–boat business in 1928, hailing spectators with a bullhorn. Of course, does a guy nicknamed "Gabby" really need a bullhorn?

Catalina once boasted a world-famous Bird Park just up and across Avalon Canyon Road from the practice field. In this image, curious players encounter ostriches just as tall as they are. Bird Park finally closed its coops in 1966, although its remains still stand.

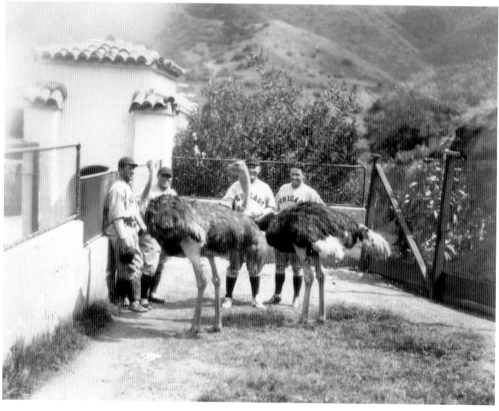

TOO MUCH SPARE TIME

Hall-of-Famer Billy Herman was a slick-fielding glove man—even when dismounted. He manned second base for 11 seasons in Chicago, and his lifetime batting average was .304.

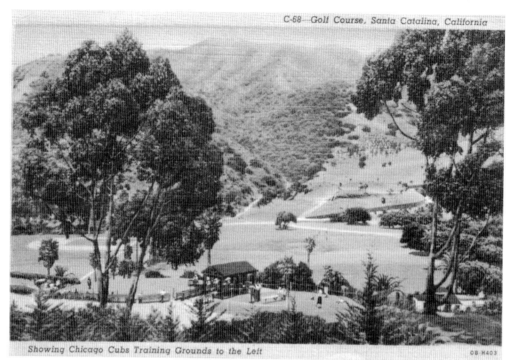

Showing Chicago Cubs Training Grounds to the Left

08-H403

Catalina's golf course is one of the two oldest in the state, dating back to 1892. (The other one is also on an island—Mare Island, near San Francisco.) It is next to the baseball diamond and known as a challenging course because of its narrow fairways that are surrounded by canyons on the left and a road to the right.

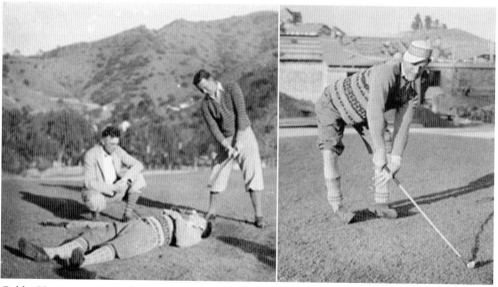

Gabby Hartnett apparently can't find a tee this particular afternoon in 1928, so he has recruited a rookie to take its place. In the image on the right, atop the hill next to the country club (under construction), Charlie Grimm works on his putting stance—without much success.

After 10 more seasons on the Island, by 1938, Gabby Hartnett and Charlie Grimm apparently got the kinks out of their game—even donning fancy matching two-tone golf shoes.

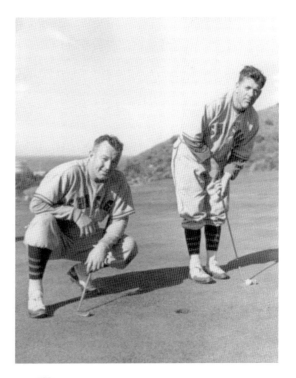

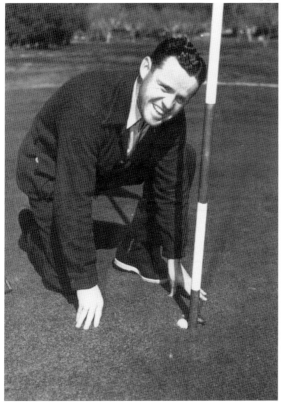

Rookie pitcher Lefty Carnett had a singular success in 1939—sinking the only hole-in-one ever hit by a Cub on Catalina. Despite his duffing skills, however, Lefty was dispatched to Milwaukee for more seasoning. He did make it to the majors, debuting with Casey Stengel's Boston Braves in 1941.

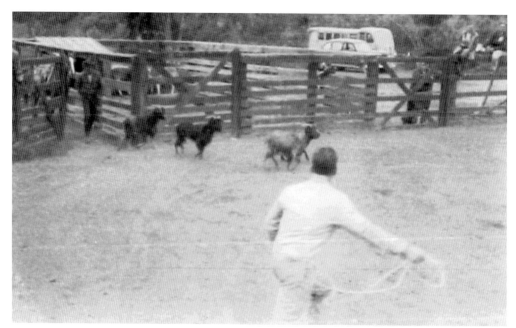

P. K. Wrigley often invited the players to a barbecue picnic and mini-rodeo at El Rancho Escondido, 12 miles from Avalon in the island's interior. In 1950, Monk Dubiel courageously tried his hand at roping. Another Cub pitcher, Warren Hacker, smartly decided to avoid dust, horns, and hooves by hanging back with his Brownie and snapping this shot. (Courtesy of Olinda Hacker.)

Hank Sauer, known on Catalina and throughout the National League for poling homers over fences, sits on this fence—poised for a quick getaway in case a bull rampages in the ring. (Courtesy of Olinda Hacker.)

TOO MUCH SPARE TIME

While the corn cooks and the beans bake, a few of the younger players take time for a photograph. Randy Jackson (front), Warren Hacker (left), Carmen Mauro, and Bob Kelly (right) smile in anticipation of the roped-and-roasted livestock they will soon consume. (Courtesy of Olinda Hacker.)

The Cubbies didn't win a lot of games in those years, but the organization was known among players for its family feel. (Courtesy of Olinda Hacker.)

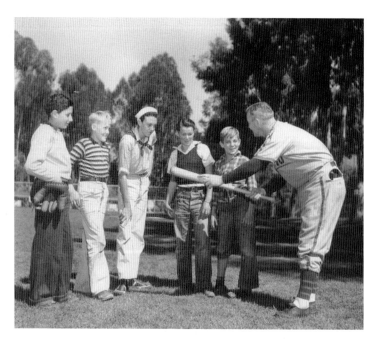

Catalina's children worshipped the players, of course, and were thrilled to shag fouls, snare autographs, and wear hand-me-down flannels. (The Cubs gave their old jerseys to Avalon High School for the prep players to wear.) "Gabby Hartnett and I played catch," recalled Jack Cowell, who grew up on the island. "He threw the ball so hard, it'd sting like crazy—but I wouldn't let him know."

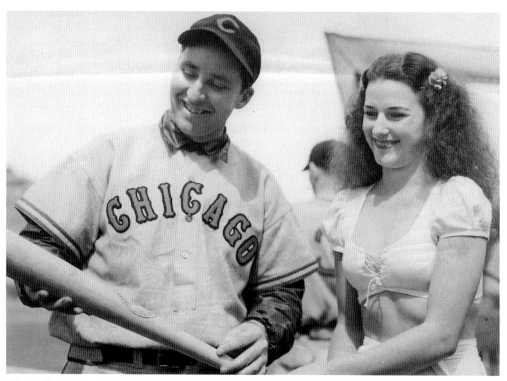

The ballplayers were quick to notice that Catalina was populated with local talent. In this 1937 photograph, Ripper Collins kindly provides islander Kay Todd with batting pointers.

TOO MUCH SPARE TIME

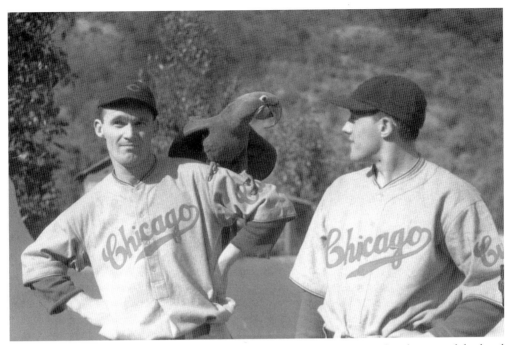

Roy Henshaw and Harry Hartnett (Gabby's little brother) get acquainted with some of the local wildlife in 1933.

When the Cubs passed their old uniforms down to the local kids, they generally didn't quite fit, but the kids didn't mind. Posing here in 1947 in their "new" game attire are, from left to right, Victor Piltch, Sylvester Ryan, Bob Thomas, and Lolo Saldaña (wearing Hack Wilson's flannels). Ryan migrated overtown (see page 83) to become the Bishop of Monterey. His dad, Spud Ryan, served as Catalina's entire police force and occasionally as a backup catcher for the Cubs when they were on the island. Today Lolo's Barbershop in Avalon is virtually a shrine to the Cubs. (Courtesy of Lolo Saldaña.)

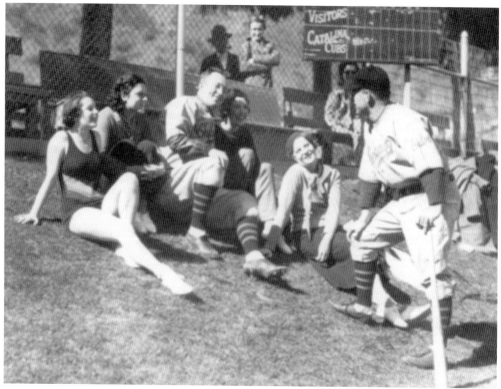

"Judging by this picture," a wire scribe wrote in 1933, "it is not all unpleasant work. Here are shown manager Charlie Grimm and Gabby Hartnett with Eloise Hovey, Kay Morrin, Kay Brown, and Dorothy Dennison. Looks like everything is pleasant, including the weather."

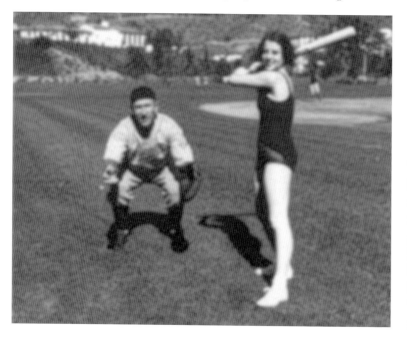

The team must have run out of old uniforms by the time the girls got there. In this image, Eloise has to bat in her bathing garb; Zack Taylor eagerly awaits the pitch.

TOO MUCH SPARE TIME

As a teenage rookie in 1927, Roy Hansen (pictured) was dispatched to a canyon bottom with a large burlap sack for a snipe hunt, which would—the veterans promised—culminate in a sumptuous snipe roast that evening. The veterans would chase the snipe downhill, they explained, so all the rookie had to do was bag them. Bag in hand, Hansen clambered down to the canyon bottom and waited . . . and waited. While most victims of this classic prank abandoned their post within minutes, the rookie lefty stayed all afternoon and through supper, finally trudging back to the hotel lobby around 9:30 p.m. to be greeted with roars of laughter and a new nickname, which "Snipe" Hansen would keep for the rest of his career. Before letting him in on the joke, however, the perpetrators added fuel to the flames, "We chased hundreds of snipe in your direction," scolded Woody English, "and you didn't even catch one!" Afterwards, Hansen recovered enough from his chagrin to enjoy five seasons in the majors. (George Brace photograph; courtesy of Mary Brace.)

ROY HANSEN
Pitcher. "Snipe" throws left handed, bats either. He is 25 years of age, weighs 195 lbs., and is 6 ft. 3 in. tall. He came up first time to the "Phillies" in 1930; was sent back for more seasoning and came up in 1932 to stay. He signed his first major contract at 17. "Snipe" is also a basketball star. His home is in Chicago.

ROY HANSEN
Philadelphia "Phillies"

In the 1930s, when Hansen was pitching for the Phillies, the Diamond Matchbook Company created a variation of the standard bubblegum baseball trading card. On Hansen's card, they identified the hurler as "Roy" on the front, but on the back managed to work in "Snipe" not once, but twice.

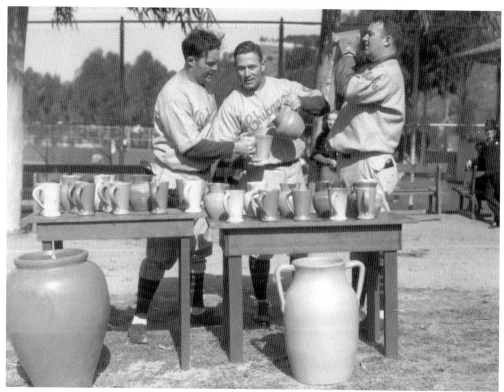

The Catalina Tile Works and Pottery Shop were world famous. In 1932, Pat Malone, Charlie Root, and Gabby Hartnett stopped by to sample the wares.

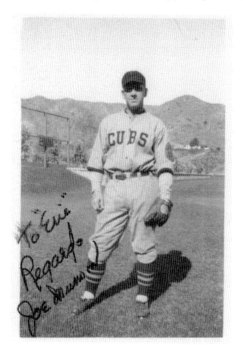

"Joe Munson has been walking around the island with a camera, taking snapshots of every gable and window," the *Chicago Daily News* reported in 1926. "He even speculated on the advisability of snapping the lights in the middle of the main street." Munson handed his Brownie off for this portrait of himself to send to an admirer. He would hit .371 as a rookie before fading to a stellar 15-year minor-league career where he smacked 208 homers (.335 lifetime) and was a one-man wrecking crew for Harrisburg one season (batting .400 and leading the league in hits, homers, triples, runs, and RBI).

TOO MUCH SPARE TIME

Years later, in 1949, Warren Hacker snapped a few of his own photographs around Avalon. His dapper roomie, Corky Van Dyke, poses here along picturesque Crescent Avenue. "I used to throw the hope ball," Corky recalls, "you'd try and get it by them, and hope you could!" Van Dyke, a distant cousin of actors Dick and Jerry, recalled some early success against a teenage Hank Aaron in the Northern League, "I used to puff him out once in a while." (Courtesy of Olinda Hacker.)

Corky wrested the camera from its owner so the home folk could see how good Warren looked out at sea, with the Pleasure Pier behind him. "He's a good guy," Van Dyke says of Hacker. "We called him 'Happy Hack.' " (Courtesy of Olinda Hacker.)

Eating well was a crucial part of the regimen. Mr. Wrigley kept the boys well fed at the Hotel St. Catherine dining room, among other locales.

TOO MUCH SPARE TIME

While the cuisine at Wrigley's hotel was world class, one has to wonder how today's ballplayers would react to "Braised Ox Joints," "Catalina Headcheese," or "Fresh Ox Tongue." It is important to note, however, that each repast was guaranteed to end on a high note: sandwiched between the beverages and the hours of service on this 1925 menu is the solemn promise, "After every meal—Wrigley's."

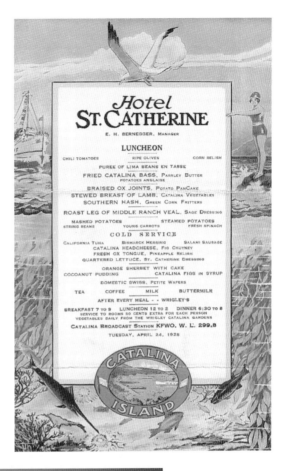

Catalina has long been "The Island of Romance." Charlie and Dorothy Root took advantage of this and cut the rug every chance they could.

Multi-talented, multi-tasking manager Charlie Grimm figured a way to combine music with calisthenics right in the hotel ballroom.

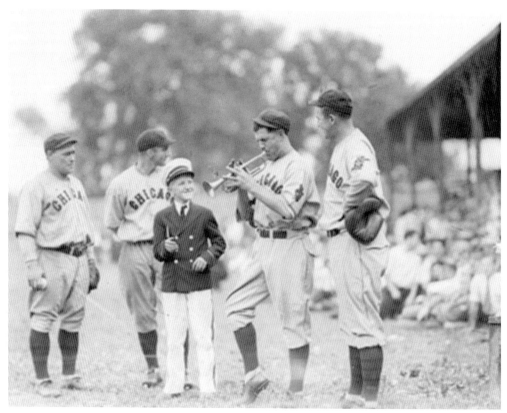

Jolly Cholly was not opposed to the outdoor marching band concept either, so he appropriated this kid's cornet to see how it worked.

TOO MUCH SPARE TIME

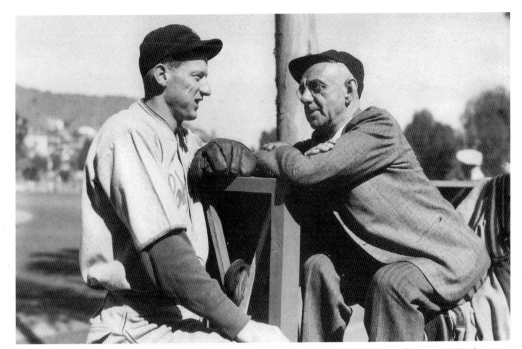

Some fans made the trek from Chicago. Retired fireman Danny Cahill, shown here in 1933 chatting with all-star pitcher Lonnie Warneke, came every year. He was considered part of the gang and sometimes even appeared in the team picture. The press gave him plenty of coverage too. "Danny Cahill was turned down on his application to join the Avalon Fire Department," the *Herald and Examiner* teased in 1927, "because he was a complete flop during the Chicago fire of 1871." When the superfan passed away, he was buried in a Cubs jacket holding an autographed ball.

Jack Doyle epitomized the bare-knuckled baseballers of the 19th century. He once got into a fistfight with an umpire for calling him out. Another time, he climbed into the stands to punch a fan. After teenage rookie Phil Cavarretta (who he had signed as a scout) got the best of him at the poker tables on Catalina in 1935, Doyle cussed him out and said, "Listen, dago—if you become half as good a ballplayer as you are a card player, you'll have a good career." Shown here in 1922 at age 53, Doyle was still slapping fungoes years later into his 60s. He scouted for 40 years until his death at 89 in 1958. He spent 70 seasons in professional baseball.

On the day his son was born, Lennie Merullo made four errors in a single game—a major-league record. Phil Cavarretta suggested the nickname "Boots" for the newest Merullo, and it stuck. Boots came along to Cubs camp a few times and was a regular mascot around Wrigley Field. Years later, Boots played for a few seasons in the Pittsburgh organization. A generation later, Lennie's grandson Matt enjoyed a six-year big-league career.

Plenty of the wives made the 1947 trip. From left to right, shown standing behind their wives, are Russ Bauer, Bob Chipman, Cy Block, Red Adams (three-year-old Lila sits on her mother's lap), Charlie Grimm, Lennie Merullo, and Ray Prim. (Courtesy of Lila Adams.)

TOO MUCH SPARE TIME

Buddy Hartnett made the voyage several times—his parents had honeymooned on the spring trip several seasons earlier—and he came back in 2003 for a reunion after an absence of many decades. (George Brace photograph; courtesy of Mary Brace.)

Charlie and Dorothy Root brought son Charles Jr. (who got a Catalina tryout with the Cubs years later) and daughter Dorothy enough times (14) that the island became their home away from home.

Bob Scheffing and his wife brought little Bobby to the island twice in 1947 and 1948. While there, Bobby Jr. watched daddy play, rode tricycles with the locals, and went sanddab fishing.

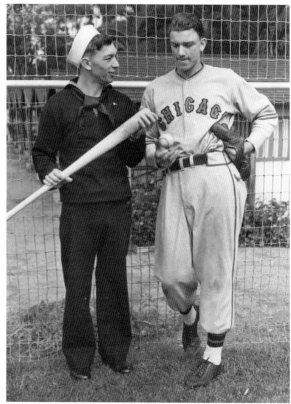

In 1937, Al Epperly was trying out with the Cubs on Catalina when his brother Hal, in the navy aboard the USS *Colorado*, stopped by on shore leave. A few months later, farther out in the Pacific, Hal and his mates led the search for Amelia Earhart.

TOO MUCH SPARE TIME

SEEING STARS

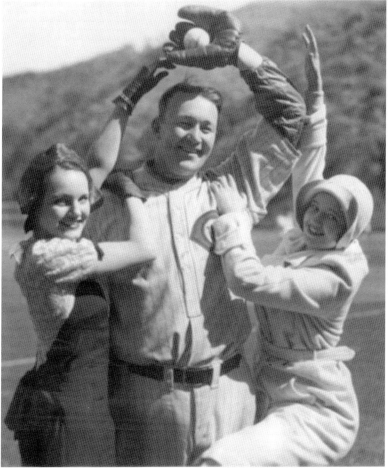

Catalina's faraway feel makes it easy to forget that it is in Los Angeles County and close to Hollywood. In the 1930s and 1940s, Catalina was a popular playground for actors, actresses, and big band musicians. The Cubs often encountered world-famous celebrities while there. And as enough years went by, some of the Cubs entourage themselves achieved fame and fortune beyond baseball: first baseman Chuck Connors, reporter Ronald Reagan, and a teenage military wife named Norma Jeane Dougherty. "I SAW HIM FIRST," shouts the caption for this 1931 publicity photograph. "Gabby Hartnett of the Chicago Cubs has promised a ball to the girl who reaches it first. Rochelle Hudson and Arline Judge, Radio Pictures featured players, reach for the baseball instead of the sweet."

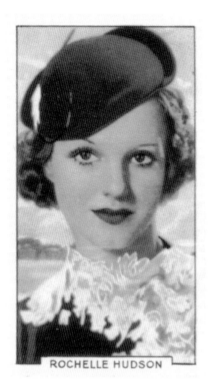

ROCHELLE HUDSON

In the 1930s, trading card companies made movie star cards as well. Here is Rochelle Hudson's rookie card. She was in 130 films (later playing Natalie Wood's mother in *Rebel Without a Cause*) and actually had her own sitcom in the 1950s called *That's My Boy*.

Arline Judge, at left, came from England. She made 53 pictures and later guest-starred on the smaller screen. At right is Phil Cavarretta's leggy ping-pong nemesis, Betty Grable. "My wife doesn't like this story," smiled Phil Cavarretta, recalling an evening at the Hotel St. Catherine in 1935. "Some of the guys were downstairs playing ping-pong, and Betty Grable was watching." Phil beat everybody, but Betty came over, grabbed his paddle, and said, "I can beat you!" In front of all his mates, Cavy's honor was on the line. "She was pretty good! I had to really concentrate to beat her." And he did.

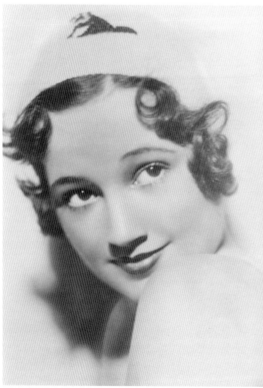

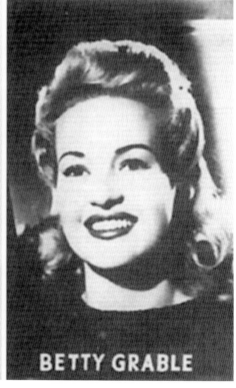

BETTY GRABLE

SEEING STARS

Before she married William Boyd (better known as Hopalong Cassidy), actress Grace Bradley dated Cubs pitcher Clay Bryant on Catalina. Grace was a big enough star that her caricature adorned the walls of the fabled Brown Derby Restaurant in Hollywood, where owner Bob Cobb (who also owned the Hollywood baseball Stars) invented the Cobb Salad.

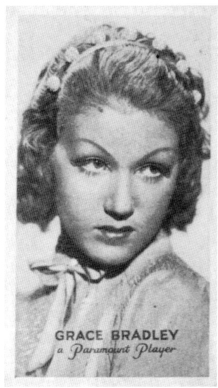

GRACE BRADLEY
a Paramount Player

Grace's rookie card includes the logo for Paramount Pictures, where she was under contract. She made several dozen movies, and at age 90 she was still leading exercise classes around Hollywood.

PRESIDENTIAL PASTIME

40th President of the United States

While president, Ronald Reagan tossed out a first pitch at Wrigley Field wearing a Cubs jacket. Yet it was far from the first time he had taken the field with the Cubbies. He first joined the team more than 50 years earlier out on Catalina. As a radio announcer for WHO in Des Moines, Dutch Reagan would "re-create" games for local listeners. Reading wire service updates, he'd call the game as if he was at the park, adding such sound effects as the crack of the bat. In 1936, he convinced WHO to send him to cover spring training. He also wrote a column for the *Des Moines Dispatch*, and the paper gladly covered his trip. On Catalina, Dutch entertained visions of playing ball. Charlie Grimm let him suit up a few times and work out with the team, and he asked Phil Cavarretta for some batting tips. Unfortunately, Cavy laments, "He had what I call a 'slow bat.'"

The press box was beside the grandstand. The grizzled old newsmen didn't like the newfangled radio medium, nor did they appreciate the whippersnapper from Des Moines who brought it. Reagan would arrive early and spread out his papers and gear over a favorite chair or two. In Charlie Grimm's autobiography, Cholly described a scene at a local watering hole one night. "There were words," Grimm wrote, and Jimmy "the Cork" Corcoran of the *Chicago American* "went into action." Corcoran swung, Dutch ducked, and the Cork's punch landed in the expansive midriff of the *Chicago Tribune's* Ed Burns.

SEEING STARS

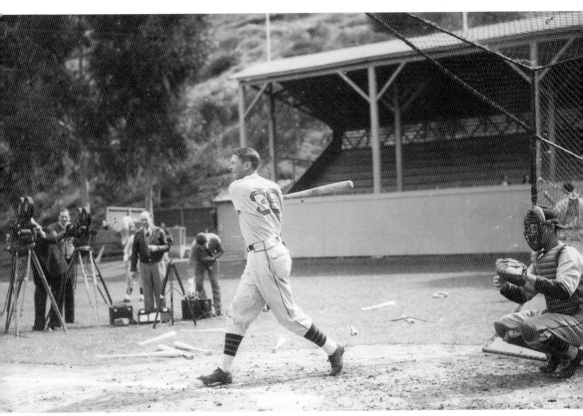

Dutch's 1936 trip went well enough that the station sent him again the next year. During this trip, he hopped overtown (see page 83) for a screen test, changing history. "I was the only radio man there," he recalled later, which this photograph demonstrates; Dutch is bending down to adjust his audio levels as the newsreel cameras whir away beside him. In the foreground, Stan Hack takes a healthy cut at the plate. Reagan would interview him for the home folks later that afternoon.

AUGIE GALAN
coach PHILA. ATHLETICS

The radio work didn't always go smoothly either. One time, in the middle of a game, the wire went dead as Augie Galan was batting for the Cubs. "I had a ball on the way to the plate, and there was no way to call it back," Dutch recalled years later. "So, I had Augie foul the pitch down the left-field line. He fouled for six minutes and 45 seconds." At last, the wire came back to life, and Augie was mercifully allowed to pop out.

In 1952, Reagan once again had a chance to don Chicago flannels when he starred as another Catalina Cub, Hall-of-Famer Grover Cleveland Alexander.

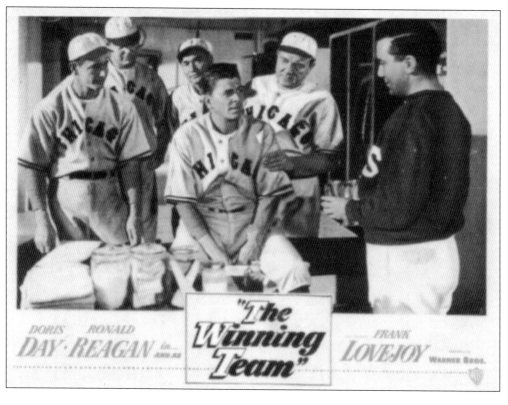

DORIS RONALD
DAY · REAGAN

"*The*
Winning
Team"

FRANK
LOVEJOY

WARNER BROS.

After tossing that first pitch in 1988, he also got to return to the Cubbie broadcast booth calling a few innings alongside Harry Caray. "You know," he said over the airwaves, "in a few months I'm going to be out of work, and I thought I might as well audition."

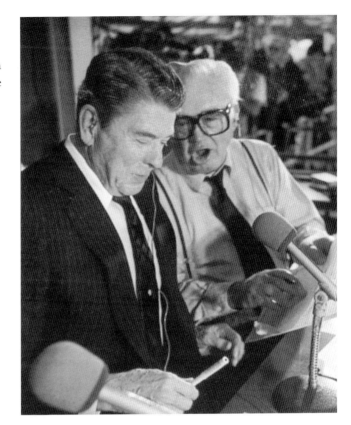

As seen in this image, Reagan toured the dugout that day, too, regaling the troops with long-lost Cubbie lore. (Courtesy of the White House.)

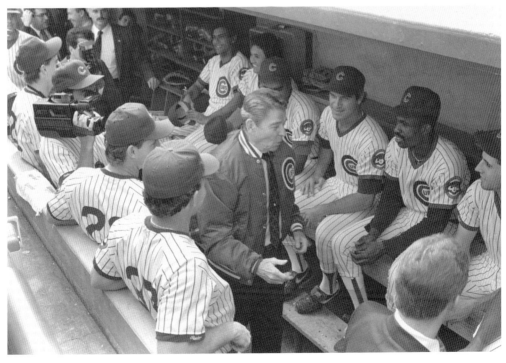

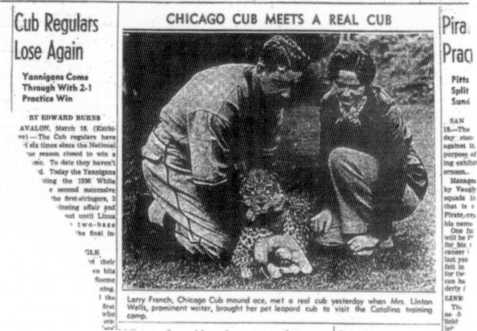

Cub Regulars Lose Again

Yannigans Come Through With 2-1 Practice Win

BY EDWARD BURNS

AVALON, March 18. (Exclusive) — The Cub regulars have ...t six times since the National ...ue season closed to win a ...me. To date they haven't ...d. Today the Yannigans ...ting the 1936 White ...e second successive ...he first-stringers, 2 ...inning affair and ...ut until Linus ... two-base ...he final in-

GLK ...f their ...o hits Sueme ning. I the first who ora- 'ars'l...

CHICAGO CUB MEETS A REAL CUB

Larry French, Chicago Cub mound ace, met a real cub yesterday when Mrs. Linton Wells, prominent writer, brought her pet leopard cub to visit the Catalina training camp.

Pira Prac

Pitts Split Sun...

SAN 18.—The day stoo against it purpose of ing exhibit ernoon...

Manage ky Vaugh squads in that is ... Pirate, res his name One fa will be ... for his ... career last yea felt in for tw can ha derty ...

LINE Th as A field lef...

Publicity shots from the 1930s were often clever, but sometimes cryptic. The caption for this image identifies the woman in the photograph (dressed suspiciously like an aviator) only as "Mrs. [Faye] Linton Wells, prominent writer."

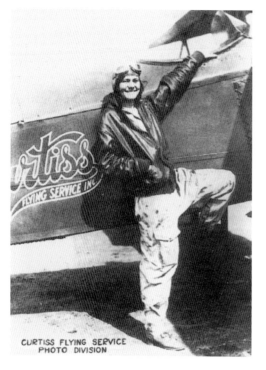

CURTISS FLYING SERVICE
PHOTO DIVISION

Shown here in 1929 at age 21 with her Curtiss Jenny, Fay Gillis Wells was one of the world's first female pilots. She flew with Amelia Earhart and Charles Lindbergh, and from her station in Siberia she assisted Wiley Post in his attempt to circumnavigate the globe. And the leopard seen in the above image? Fay had covered the Ethiopian War, and the cub was a gift from the locals. Back in the United States, she covered Hollywood for the *New York Herald-Tribune*. While on assignment in Southern California, she and her husband, Linton Wells, a fellow correspondent, went to Catalina and stayed at the Hotel St. Catherine alongside the team. "The bellboys took care of Snooks [the leopard] and sat her on the front desk. Everyone went bananas, and they all wanted pictures with her," Fay recalled years later.

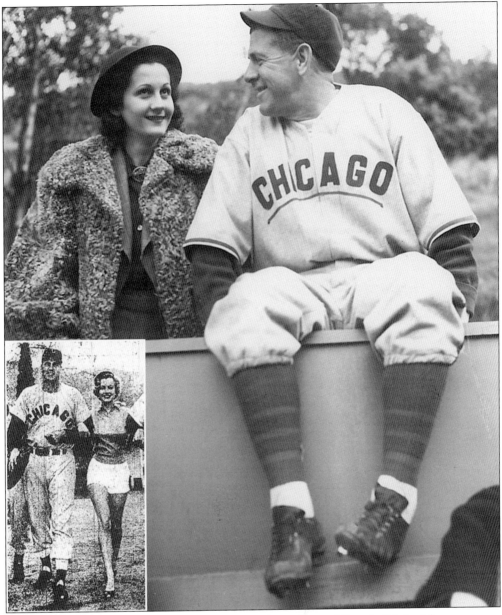

Actress Gail Patrick made 62 films and co-owned the Hollywood Stars ballclub with restaurateur husband Bob Cobb. They'd sometimes hop over to Catalina to talk shop with Charlie Grimm and their other Cub pals. Patrick was later the executive producer of television's *Perry Mason*. Before becoming Marilyn Monroe (inset), 16-year-old Norma Jeane Dougherty lived on Catalina with her merchant marine husband. Later on, Monroe posed for some publicity photos at a Southern California spring-training session. Here Chicago slugger Gus Zernial escorts her across the diamond. "We talked a little about baseball," Gus recalled much later, "how the game was played, just chit-chatting back and forth about hitting and fielding." Legend has it that when Joe DiMaggio saw this picture in the paper, he told his agent he wanted to meet Monroe.

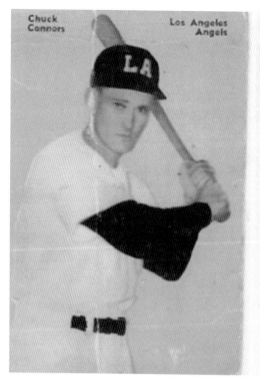

Chuck Connors

Los Angeles Angels

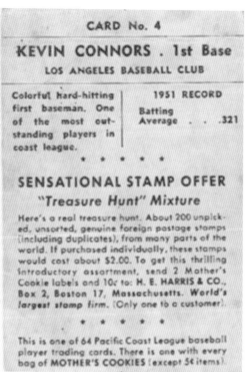

CARD No. 4

KEVIN CONNORS . 1st Base
LOS ANGELES BASEBALL CLUB

Colorful hard-hitting first baseman. One of the most outstanding players in coast league.	1951 RECORD Batting Average . . .321

* * * * *

SENSATIONAL STAMP OFFER
"Treasure Hunt" Mixture

Here's a real treasure hunt. About 200 unpicked, unsorted, genuine foreign postage stamps (including duplicates), from many parts of the world. If purchased individually, these stamps would cost about $2.00. To get this thrilling introductory assortment, send 2 Mother's Cookie labels and 10¢ to: H. E. HARRIS & CO., Box 2, Boston 17, Massachusetts. World's largest stamp firm. (Only one to a customer).

* * * * *

This is one of 64 Pacific Coast League baseball player trading cards. There is one with every bag of MOTHER'S COOKIES (except 5¢ items).

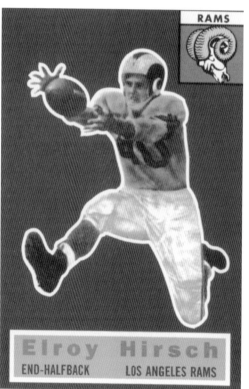

RAMS

Elroy Hirsch

END-HALFBACK LOS ANGELES RAMS

Another future star, Chuck Connors, also spent time with the Cubs on Catalina. The front of his 1952 Mother's Cookies card calls him "Chuck," and the back calls him Kevin, his given name. "Connors was crazy," Randy Jackson remembered. "He'd do anything. He'd lie down in front of moving cars, right on the street!" Why did he switch careers? After he got his first check for acting in a movie—$500 for one week's work—Connors remembered thinking, baseball just lost a first baseman.

NFL Hall-of-Famer Elroy "Crazy Legs" Hirsch was still in the U.S. Marines when he had a Cubs tryout on Catalina in 1946. "He has quite a reputation as a hitter," the *Chicago Sun's* Mouse Munzel noted. "He'll make up his mind between baseball and football when he gets his discharge." His 1957 Topps (football) card tells the rest of the story—and illustrates those crazy legs.

OVERTOWN

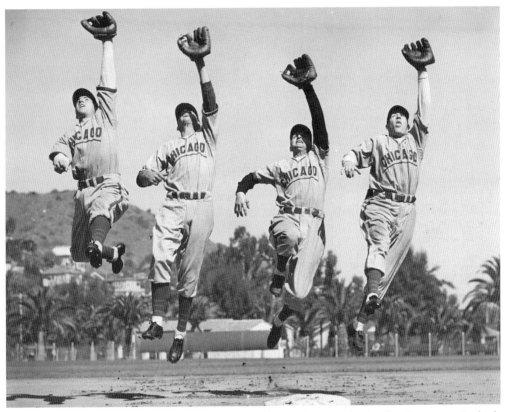

Many big cities have a downtown, uptown, and midtown, but tiny Avalon has "overtown," which is how the locals refer to the mainland. (An islander planning a trip to Los Angeles is likely to say, "I'm going overtown tomorrow.") When the Cubs broke Catalina camp, they would head overtown for more adventures. Once overtown, the Cubs played exhibition games in Los Angeles at *that* Wrigley Field. The Los Angeles Angels of the Pacific Coast League were also owned by the parent corporation, so the fit was a natural. The park was built in 1925 and resembled the one in Chicago in a lot of ways. (Ironically, it was at the corner of Forty-second and Avalon Streets.) Plenty of movies and television shows were filmed there, including *Home Run Derby*. History's first Wrigley Field was demolished in 1966.

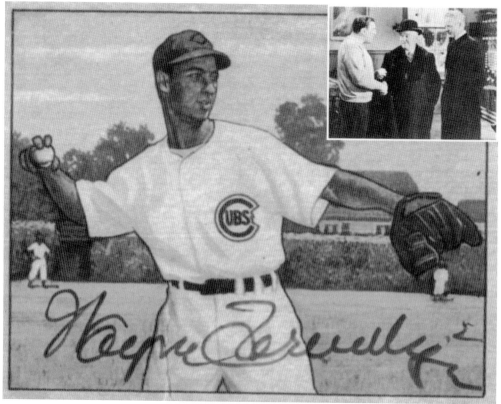

Los Angeles's Wrigley Field, like Catalina's, showed up on some baseball cards. Wayne Terwilliger's 1950 card (seen here) shows the Los Angeles park's ivy-covered walls. William Frawley (inset, center), *I Love Lucy*'s Fred Mertz, co-owned the PCL's Hollywood Stars with Cobb and Patrick. In 1961, he was on the board of the Los Angeles Angels. This card comes from the 1948 card set that accompanied *The Babe Ruth Story*. Frawley played the manager who signed the Babe to his first contract.

When overtown, players stirred up mischief that wasn't possible on the island. Greek George only had a .177 lifetime average, but he was one of Bill Veeck's all-time favorites, reflecting, "Any time I wandered around with him, something was going to happen." Sitting beside the catcher on a Ferris wheel, Veeck got nervous when George began beaning heads below with Eskimo Pies. At ride's end, they had to scramble off "through a bitter and angry crowd, a crowd reeking of vengeance and ice cream."

OVERTOWN

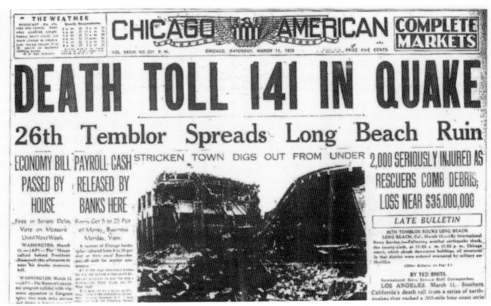

DEATH TOLL 141 IN QUAKE

26th Temblor Spreads Long Beach Ruin

ECONOMY BILL PASSED BY HOUSE | **PAYROLL CASH RELEASED BY BANKS HERE** | STRICKEN TOWN DIGS OUT FROM UNDER | **2,000 SERIOUSLY INJURED AS RESCUERS COMB DEBRIS; LOSS NEAR $35,000,000**

LATE BULLETIN

The Long Beach earthquake of 1933 was a significant disaster, and the Cubs had just landed overtown when it hit. Many players were staying at the Biltmore Hotel in downtown Los Angeles, which swayed back and forth precariously. Gabby Hartnett's wife, who was bathing son Buddy, pulled on her dress backwards as they ran out onto the street. But Martha did better than ballplayer Charlie Berry, who was getting a rubdown at the time. He ran outside au naturel.

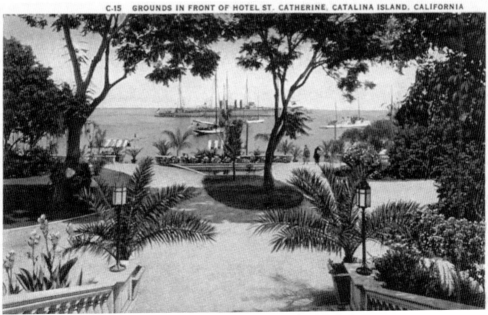

C-15 GROUNDS IN FRONT OF HOTEL ST. CATHERINE, CATALINA ISLAND, CALIFORNIA

Events well beyond Catalina had an impact on the training schedule. This postcard, intending to be a blissful image of the Hotel St. Catherine grounds, shows a warship ominously patrolling the water in the late 1930s.

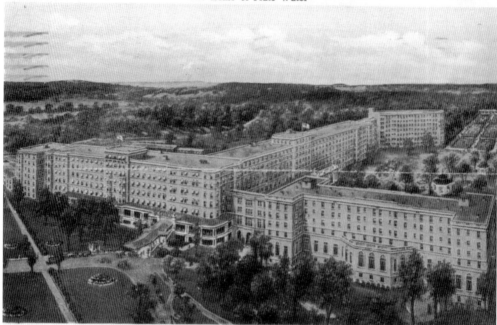

French Lick Springs Hotel, French Lick, Ind. 124156-N

World War II travel restrictions meant teams had to train closer to home. The Cubs chose French Lick, Indiana—home of Pluto Water, which is described in detail in the book, *French Lick and West Baden Springs*.

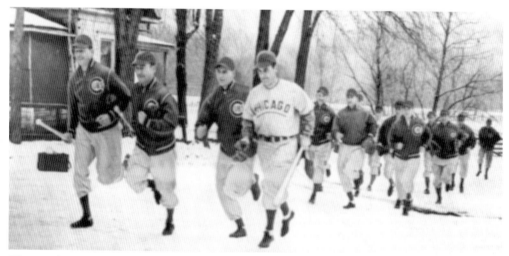

The conditions at French Lick were ludicrous. "It was so cold," Phil Cavarretta said, "even the horse droppings were frozen." This photograph from the *Chicago Tribune* sports section showed the 1944 team dashing through the snow, with a caption reading, "Who named it spring training? The Cubs do not have to hustle like this—they have the alternative of freezing—as they go from their horse barn training headquarters to the hotel in French Lick, where they opened practice yesterday. Someone said it was the first day of spring, but they had little evidence of that fact."

The Cubs won the National League pennant in 1945, so the first post-war World Series came to Wrigley Field. The Detroit Tigers prevailed in the series, and at last the war was over, so the Cubs were able to return to Catalina the next spring.

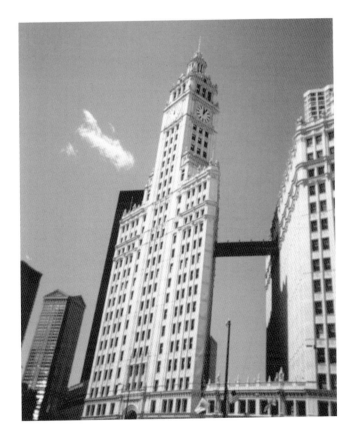

The Wrigley Building went up in the early 1920s, around the same time William Wrigley took over both the Cubs and Catalina Island. Always the innovator, his tower was the first air-condition office building in Chicago. The company is still headquartered there after all these years, and its familiar design is a landmark on Michigan Avenue.

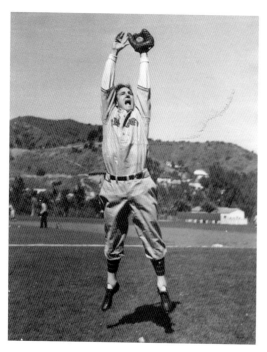

Billy Jurges enjoyed a solid 17-year big-league career and was an all-star shortstop during the Cubs' glory seasons. He also partly inspired Bernard Malamud's *The Natural*, since he was shot by a distraught former girlfriend in a Chicago hotel in 1932. Unlike Roy Hobbs, Billy recovered quickly—playing 115 games that season despite being plugged in July.

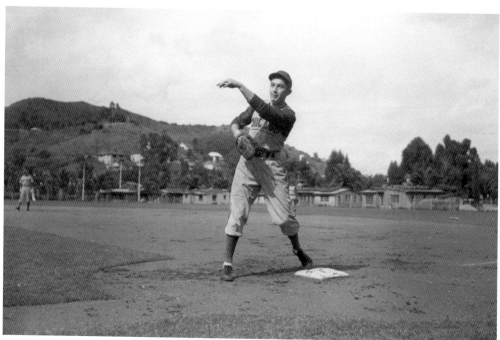

In June 1949, a second Cub, Eddie Waitkus, was shot in a Chicago hotel by a deranged admirer. Waitkus had recently been traded to the Phillies, and the fan went over the edge realizing that she wouldn't see him play as often. Eddie's injuries were more severe than Billy's, but he bounced back to play all 154 games in 1950—even gathering four hits in the World Series for the "Whiz Kids."

A COLORFUL CAST
OF CHARACTERS

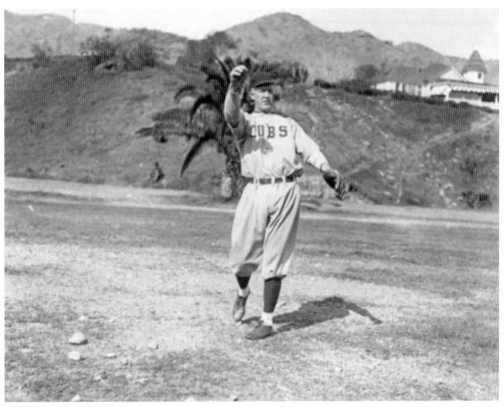

Over the years, several hundred Cubs hopefuls practiced on Catalina—including 16 Hall-of-Famers (not counting the players on visiting teams). Between 1921 and 1951, the Cubs won five National League pennants. And some of the personalities of the men associated with those years are much more fascinating than any fiction. Grover Cleveland "Alex" Alexander (seen here) was such a superstar that Hollywood made his life story into a movie (where he was portrayed by another gent with Cubs/Catalina ties, Ronald Reagan). How good was Alex? He won 30 games for three straight seasons and once pitched 16 shutouts in a single year. He went to Catalina for the first half-dozen trips, and after he retired he came back several more times as a coach and batting-practice pitcher.

Alex and former battery mate manager Bill Killefer, seen here taking a break in 1922, knew each other well. They played together 11 seasons, and Reindeer Bill managed Old Pete five years on Catalina. When Alexander's biopic (The Winning Team) hit the silver screen in 1952, the script appropriately called for Killefer to play a key role.

Veteran Guy Bush offers some tips to rookie Granville Miller in 1928. Bush, one of the Cubs' all-time winningest pitchers (152 over 12 seasons, plus 1 more in the 1929 World Series), was a greenhorn himself a few years earlier. While pitching on Catalina in 1923, he broke a batter's wrist. The vets told him he would be fined, but the small-town Mississippi boy said he had no money. No problem, they assured him, he would simply go to jail instead. But he got his revenge on the train ride back. Since they thought they had an easy mark, the lads invited Bush to cards—he cleaned their clocks.

A COLORFUL CAST OF CHARACTERS

Hack Miller uprooted trees with his bare hands, drove in nails without a hammer, hoisted the piano at the Hotel St. Catherine, and pulled cars by a rope—with his teeth. He could hit, too: .352 in 1922, a Cubs rookie record that still stands. The press loved him, of course (he's seen in the upper right of this 1923 *Chicago Tribune* pictorial, hoisting teammates Cliff Heathcote and Fred Fussell). "If he does not succeed in elevating himself as one of Killefer's regular outfielders," Oscar Reichow dispatched to the *Chicago News* from Catalina, "the club can carry him around through the season as a side attraction." Unfortunately, with all that muscle, Hack couldn't move in the outfield. Long before the designated hitter rule, he was relegated to working the docks in San Francisco after a brief (six seasons) yet eventful (.323 lifetime) big-league career.

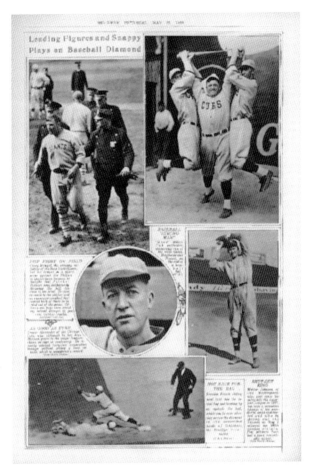

Pat Malone possessed Hall-of-Fame talent, averaging 20 wins a year during his first three Cub seasons, but he drank it away. In 1931, he beat the daylights out of two sportswriters, and a few seasons later his career was over. He died at 40.

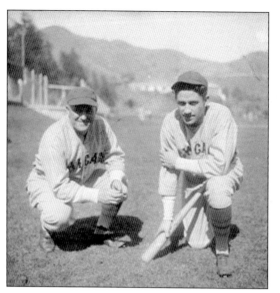

Hall-of-Fame skipper Joe McCarthy and Hall-of-Fame outfielder Kiki Cuyler take a break in 1928. McCarthy, though less famous than Stengel or McGraw, is arguably the best manager of all time, having won nine pennants and seven World Series, and he never finished lower than fourth. Cuyler had a .321 lifetime average over 18 seasons and appeared in three World Series for the Cubs. He won several dance contests on the island and was "the closest approach baseball ever had to a matinee idol," according to his next skipper, Charlie Grimm.

Mike Gonzalez caught in the National League for 17 seasons before becoming the first Cuban-born manager in the majors. As a scout, he coined the term "good field, no hit." A national hero in his homeland, his parallel Winter League career exceeded his U.S. heroics; he owned a team in Havana and was referenced in Ernest Hemingway's novel, *The Old Man and the Sea*, in which old Santiago calls him one of the two greatest managers in the game.

Lefty O'Doul hit .398 in 1929 and had a .349 lifetime average in the majors. He later became a hero in the PCL (managing from 1935 to 1957, cultivating talent like Joe DiMaggio) and Japan (arranging goodwill ball games after the war). San Francisco even named a bridge after him. And yet, after a 1926 tryout in Catalina, the Cubs cut him. "Later on," Warren Brown wrote in his 1946 team history, "when O'Doul broke back into the National League and either led it in hitting or caused damage to some Cub pitching hopes, Wrigley would sigh: 'Oh, that O'Doul . . . my O'Doul!' "

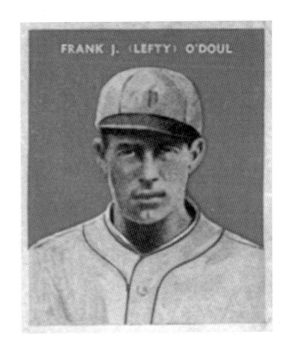

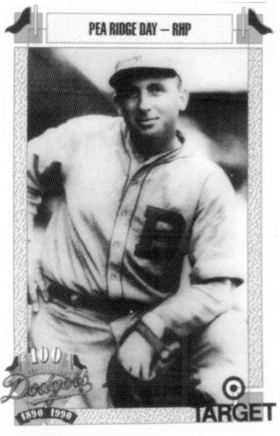

Clyde "Pea Ridge" Day (named after his Arkansas hometown) eventually pitched in four major-league seasons but never made a Cubs roster either, partly because he had a hard time getting to Catalina in 1929. After Day missed the train, "Manager McCarthy ventured the opinion that Clyde may have conceived the idea of traveling from Pea Ridge to California in a covered wagon," Ed Burns wrote for the *Chicago Tribune*. "If Clyde has done this, he will be tendered his contract and permitted to proceed just as if he hadn't vexed the management all this anxiety." Day was late for other reasons—his mother died that year—and he didn't make the team.

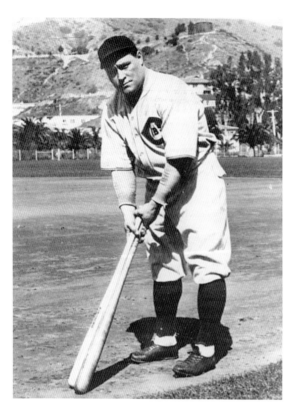

In 1930, Hall-of-Famer Hack Wilson, all 5 feet, 6 inches of him, smacked 56 homers, batted .356, and knocked in 191 runs (still a single-season RBI record). One spring day in 1931, reported the *Chicago Times*, Hack "got ahold of one and drove it farther than any ball was ever hit on Catalina Island." But that season, his numbers plummeted from too much strong drink. He had just 13 dingers, a puny 61 RBI, and a .261 average. "I see three balls coming at me and always swing at the one in the middle," he kidded, but it was no joke; the Cubs dumped him, and three seasons later he was finished.

Kirby Higbe wrote in *The High Hard One* that he loved arriving in Catalina, "Where a boy can get along just fine without an overcoat." The next spring, he disappeared somewhere between Chicago and Kansas. "So far," Warren Brown wired back to the *Chicago Herald and Examiner*, "no reward has been offered for the missing pitcher." This, and plenty of other antics, led Brown to conclude, "He showed possibilities as a pitcher, but he also showed possibilities as an eccentric." While training on another island, Cuba (with the Dodgers), Hig would go drinking (and brawling) all night with Ernest Hemingway. Despite winning 22 games in 1941, Hig led the league in walks four times and was traded repeatedly.

A COLORFUL CAST OF CHARACTERS

As a teenage rookie in 1936, Johnny Hutchings stepped off the boat, looked around at all the Spanish-style architecture and the mariachi-like troubadours, and asked Manager Charlie Grimm, "Say, Mr. Grimm. I thought we were going to Catalina Island. Isn't this place Mexico?" After a few more years of conditioning in the minors to gain his bearings, Johnny pitched six seasons in the Show (including the 1940 World Series).

Joe Marty is a legend in the old Pacific Coast League, particularly Sacramento, where he starred for the Solons for years and maintained a tough-guy saloon next to the ballpark. His big-league career wasn't quite as illustrious, but he started with a bang. As a rookie in 1937, he convinced everyone right away that he would land a starting spot. "Manager Grimm was sure of it, the islanders were sure of it, and even the seals barked in approval," wrote John Hoffman of the *Chicago Daily Times*.

CHICAGO CUBS BASEBALL ON CATALINA ISLAND

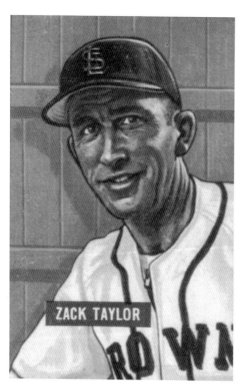

ZACK TAYLOR

Zack Taylor caught for 16 major-league seasons, including the 1933 spring session that included an earthquake. Taylor, dining at Charlie Root's home overtown, kept his hat and gloves on afterwards (despite the warm weather), so he could be ready for a quick getaway. He is best remembered, however, for being the St. Louis Browns manager who inserted a midget in the lineup.

At fellow former Catalina Cub Bill Veeck's behest, Zack Taylor pinch-hit Eddie Gaedel (all 3 feet, 7 inches and 65 pounds of him) in a 1951 game against Detroit. Gaedel, wearing No. 1/8, drew a walk. The commissioner, not amused, immediately amended the rules so that it could happen no more.

426 **BASEBALL SC⚾⚾PS** EXTRA ...

ST. LOUIS, AUG. 19, 1951 Ptd. in U.S.A. Ⓒ NCI

Midget Pinch-Hits for St. Louis Browns

Steve Mesner had a nice major-league career (six seasons) and a great minor-league career (18 seasons, with a lifetime .311 average). After that, he stayed in baseball—sort of—by operating a batting-cage arcade in San Diego. As a player, he was a bit challenged in the field, leading the league's third basemen in errors twice. In one game on Catalina in 1937, the crowd broke into applause when he handled a pop-up properly. Unfortunately, according to Irving Vaughn of the *Tribune*, "Steve was so busy accepting the congratulations, he forgot there was a runner on base. By the time he awakened, Billy Herman had scooted from first to second."

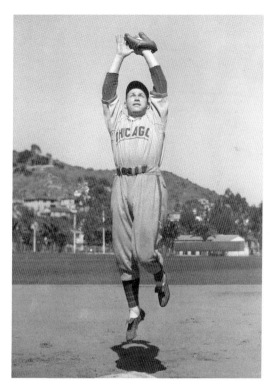

Prince Oana is famous for being the first native of Hawaii to make the majors (in 1934, for the Phillies), but by then another Hawaiian native had already donned a Cubs uniform. Clarence Kumalae got a tryout with Mr. Wrigley's Los Angeles Angels in 1933, earned a spot on the semi-professional Catalina Cubs, and was chosen to be a batting-practice pitcher for the parent club. He spent years with the organization in Catalina, Los Angeles, and Chicago, but he never did make the big-league roster. (George Brace photograph; courtesy of Mary Brace.)

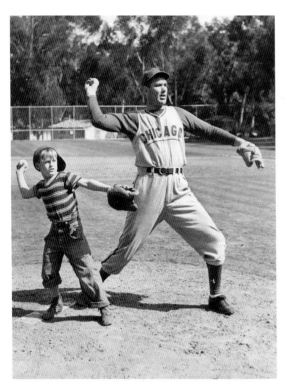

Dizzy Dean was a superstar, a celebrity, and a phenomenon in his heyday. Most baseball fans know his glory years were with the Gashouse Gang Cardinals (30-7 in 1934), but Diz gutted out a few years with the Cubs after his arm was shot. He even appeared in a World Series for the Cubbies (1938) before heading to the broadcast booth, where he earned a reputation for his Yogi Berra–ability to mangle the language.

Billy Rogell finished his career with the Cubs in 1940, making his final spring trip to Catalina. But he is best known as shortstop for the powerful Detroit Tigers of the 1930s, manning his post for 10 seasons and back-to-back World Series appearances (including one against the Cubbies). In the 1934 Fall Classic, he achieved some notoriety for plugging Dizzy Dean in the forehead while Diz was running the base paths. According to legend, newspaper headlines read, "X-rays of Dean's head reveal nothing." Dizzy always drew a laugh delivering that line, but it didn't actually appear on the sports pages that way. Nonetheless, as a publicity stunt before the next game, the two shared a photo opportunity in which Rogell presented Dean with an army helmet.

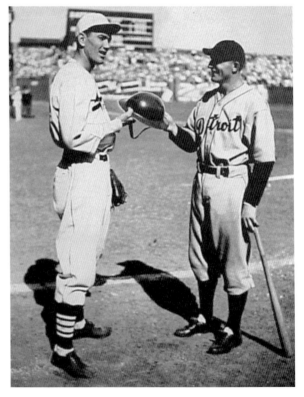

A COLORFUL CAST OF CHARACTERS

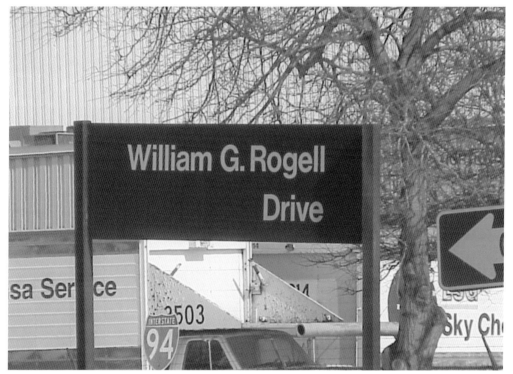

After baseball, Rogell probably became the only Catalina Cub to have a street named after him. He was a city councilman in Detroit for 40 years and was instrumental in Detroit Metro Airport's growth; today, the entrance road to the airport is called Rogell Drive. (Courtesy of Marques Thomy, the Detroit Metro Airport Authority.)

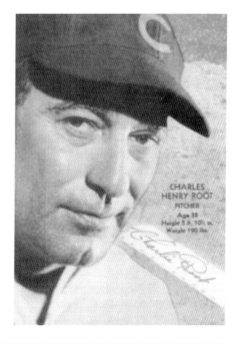

Charlie Root and his 201 Cub wins belong in the Hall of Fame, but he's most famous for one pitch and something that never happened. Charlie was on the mound when Babe Ruth pointed (according to myth) in the 1932 World Series before belting a home run to the very spot he had just pointed to. But such fancy ignores the bulk of contemporary evidence. No reporters noted any pointing that day. And Root's nickname wasn't "Chinski" for nothing; if Ruth had indeed "called his shot," Johnny Klippstein explained, "Charlie would've decked him!" Though the Babe admitted to Hal Totten, "I'd have been a fool to point at a pitcher like Charlie Root," he played up the legend once it got started. Years later, when the 60-year-old Root was pitching Cubs batting practice, a springtime rookie mimicked Ruth's alleged gesture. Root decked him on the next three pitches.

Lonny Frey played in the majors for 14 years, and at the time of his death in 2009 was the second-oldest living major-league veteran and the oldest living all-star. He didn't really enjoy Catalina. "You're tied up, you can't do anything," he said, years later, "I just wouldn't like to ever live on an island. I went to Hawaii—and I couldn't wait to get home. Did I ever go back to Catalina? Are you kidding? I'm a city boy."

Frey felt the 1937 Cubs should have won the pennant, and he was disappointed after they blew a six-game September lead. "All the wives were out shopping already!" he recalled. Trades helped him, and he got to go to World Series with the Reds and Yankees, although "I never could understand what Stengel was saying," he admits.

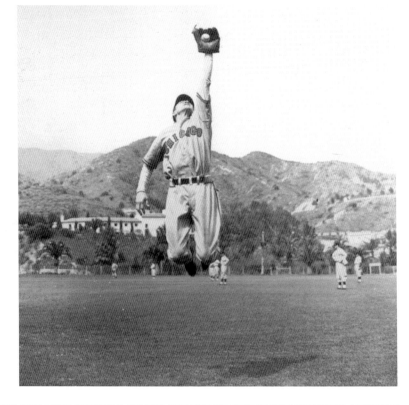

Tuck Stainback started strong for the Cubs (a .306 average as a rookie in 1934), but he fizzled to a workmanlike 13-year career. In fact, his most significant Cub moment might be his being traded for Dizzy Dean. He loved getting around on the island, dancing and dining, and often battled the scales. "All that I am today," he told the press in the spring of 1935, "I owe to home cooking."

Hank Majeski (1937) is another Catalina Cub whose big-league record doesn't show he ever played for Chicago. His "official" career, from 1939 to 1955, included six teams and a World Series appearance for the Indians in 1954. He clobbered the Northern League in 1936 (a .365 average, with power), but the Cubbie infield was impossibly crowded: perennial all-stars Stan Hack and Billy Jurges manned third and short, with Hall-of-Famer Billy Herman at second. There was nowhere for Hank to go, so the Cubs sold him to Casey Stengel's Boston Bees.

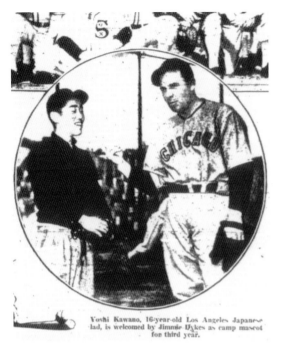

Back in the 1930s, a teenager from Los Angeles, Yosh Kawano, started working as a batboy and general gofer at baseball training camps around Southern California. During spring training, he worked with the Cubs on Catalina and the White Sox in Pasadena; during the regular season, he helped the Los Angeles Angels and San Diego Padres of the old Pacific Coast League.

Yoshi Kawano, 16-year-old Los Angeles Japanese lad, is welcomed by Jimmie Dykes as camp mascot for third year.

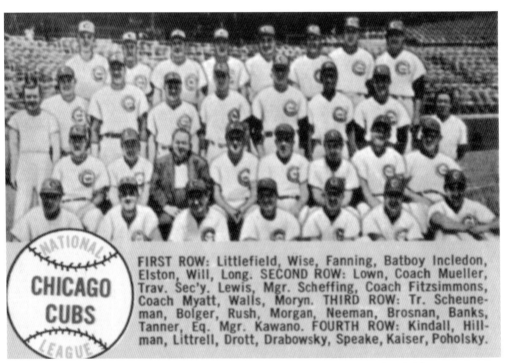

FIRST ROW: Littlefield, Wise, Fanning, Batboy Incledon, Elston, Will, Long. SECOND ROW: Lown, Coach Mueller, Trav. Sec'y. Lewis, Mgr. Scheffing, Coach Fitzsimmons, Coach Myatt, Walls, Moryn. THIRD ROW: Tr. Scheuneman, Bolger, Rush, Morgan, Neeman, Brosnan, Banks, Tanner, Eq. Mgr. Kawano. FOURTH ROW: Kindall, Hillman, Littrell, Drott, Drabowsky, Speake, Kaiser, Poholsky.

Two decades later, in the 1950s, Yoshi had become a fixture as the Cubs clubhouse man not only during spring sessions on Catalina (and later Arizona), but full-time at Wrigley Field in Chicago. In fact, he appeared on several Topps team cards, which sometimes mentioned his name on the front.

Four decades later, when the Cubs unveiled their walk of fame inside the ballpark, Yosh was included. By then, the home-team clubhouse had been named after him . . . although his permanent assignment had become clubhouse superintendent for the visiting team. Ryne Sandberg thanked him in his Hall-of-Fame induction speech and has suggested elsewhere that Wrigley Field should be renamed Yosh Kawano Field.

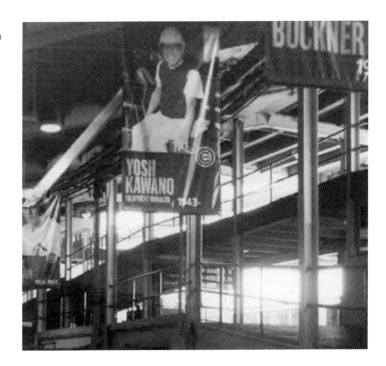

The next decade, during a Cubs reunion on Catalina, the usually quiet Kawano regaled the crowd with tales about Hub Kittle's dancing prowess at the Casino, Frankie Frisch's golfing on the island, and his own concerns about the trains staying on the right track at night. ("What if the train goes to Detroit instead of Los Angeles?" he wondered.) After eight decades in major-league baseball, Yosh finally retired in 2008.

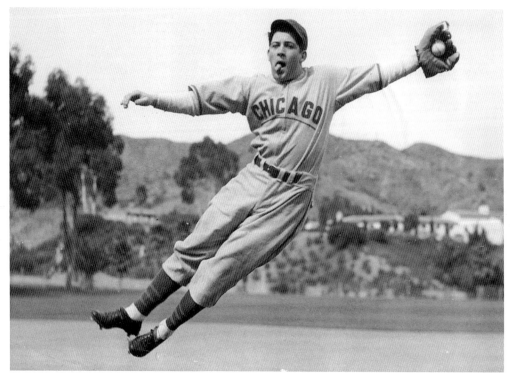

Rookie infielder Bobby Mattick displays his unorthodox fielding style in 1938. Mattick was one of the last remaining Catalina Cubs to don a uniform (when he was the Toronto Blue Jays' first manager in 1980), and he was still scouting when he passed away in 2004. Toronto's spring-training center is now named after him, and he's in the Canadian Baseball Hall of Fame.

Lefty Carnett had several different baseball careers. He pitched for the Boston Braves in 1941, pitched and played starting outfield for 1944 White Sox, and patrolled the outfield for the Indians in 1945. Around that, he played in the minors for 19 other seasons (he is one of the few members of the 100/100 club: 129 wins, 114 homers, and a lifetime .314 average), and managed six seasons in the minors too. In 1948, as manager of the Borger Gassers, he hit .409 with 33 homers and 59 doubles—and won 5 games on the mound. In 1939, he had a Cubs tryout on Catalina. While there, Lefty carded a hole-in-one on the golf course.

A COLORFUL CAST OF CHARACTERS

Before Joe DiMaggio made Casey Stengel a genius, Case piloted the Boston Braves to a seventh-place finish in 1941 (the same season Ted Williams was batting .406 across town). Lefty Carnett had a good spring and was up with the club in April. In the middle of a shellacking, Stengel suddenly told him to get in and pitch—without the benefit of warming up. Lefty wanted to get into the game, but he didn't want to risk arm damage, and he protested the move. Stengel offered Lefty some new nicknames, Carnett returned the favor, and the two almost came to blows. Within days, Lefty was on his way to the Yankees organization.

MANAGER
CASEY STENGEL

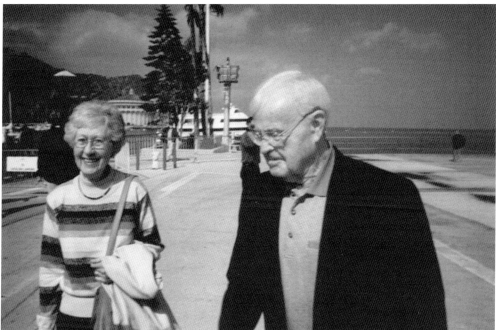

Lefty returned to Catalina for the 2003 reunion—his first trip back in 64 seasons. He married his sweetheart Marilee 62 years earlier, in 1941, so despite all that time she had never been there at all. At 88, he was still golfing his age back home, so he made sure to visit his old hole-in-one grounds, too.

Tony Lazzeri achieved Hall-of-Fame status as a Yankee infielder during the Babe Ruth era, but the Cubs gave him a couple chances in 1938 and 1940 at the end of his career. Ironically, it was Tony (not the Babe) who was the first professional ballplayer to smack 60 home runs during a season; Lazzeri beat Ruth by one year, achieving his feat with Salt Lake City in the Pacific Coast League in 1925. By the time he got to Catalina, the team relied on him to pass along some tips to the younger players.

Claude Passeau pitched the best game in World Series history until Don Larsen tossed a perfect game 11 seasons later. In 1945—the last time the Cubs got there—Passeau one-hit Detroit. He spent 13 seasons in the Show, mostly with Chicago, leading the league in whiffs (1939) and chalking up 20 wins the next year. He was old school, in the Chinski Root mold. Once, after teammate Hank Sauer hit a homer in practice, Passeau decked him during the next at-bat. "Try hitting it that way," Claude shouted, with Hank still in the dirt.

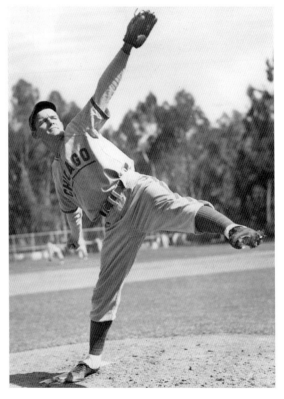

A COLORFUL CAST OF CHARACTERS

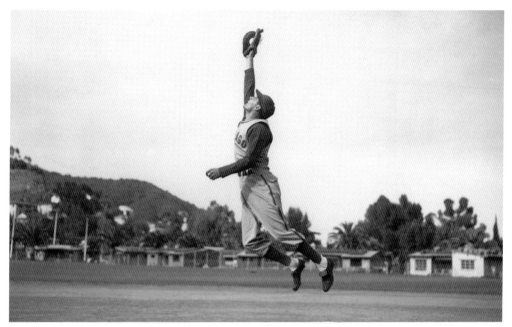

Phil Cavarretta "must have been the inspiration for whoever coined the phrase, 'He came to play,' " longtime skipper Charlie Grimm once observed. The 1945 National League MVP (who led the Cubs to their final World Series that year) broke in as a 17-year-old rookie in 1934. Before a game, Babe Ruth told him, "You should be in high school!" The Chicago product later managed the Northsiders. In fact, as hustling player-manager in 1951, he led the league in pinch hits.

After his playing career, Cavy managed in the minors for nine seasons, scouted and coached with the Detroit Tigers for years, and was a hitting instructor for the Mets until 1978—five decades in major-league baseball. Later on, he moved to Atlanta to be closer to the grandchildren and was still golfing strong at age 87 in 2003.

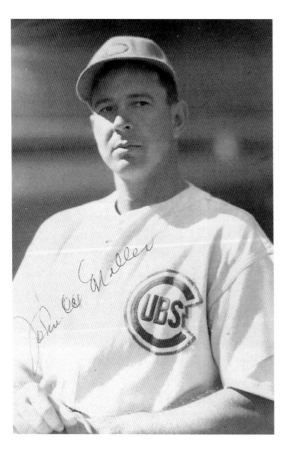

John "Ox" Miller, no relation to Hack, visited Catalina with the Cubs at the tail end of his career in 1947, but he had acquired his nickname early on. "I pitched both games of a double-header in Lincoln, Nebraska, out in the Western League," he recalled years later. "The morning paper came out and said, 'That young John Miller is strong as an ox.' The papers were competing, and the evening paper came out and said, 'He's as dumb as an ox—he's gonna hurt his arm!'" Ox went out with a bang: although he only pitched in four games that final season, he smacked a grand slam to help the Cubbie cause.

"Andy Lotshaw's Cub training room was like a vaudeville stage most of the time," said Charlie Grimm. Armed with every home remedy known to man—and some new ones that only existed in his mind—Andy was Yogi Berra before Yogi was. He was known far and wide for his malapropisms: "Now, when we get to Avalon, don't run off right away. Congratulate on the pier so they can get a picture;" or "Chuck Klein is still having charlie horses—it's become chronicle;" and "Do I believe in God? Of course. What do you think I am, an amethyst?"

"Lotshaw, he was no dummy," Bobby Mattick clarifies, "although he liked to act like he was." Andy applied more psychology than liniment to help rookies and veterans alike. "He'd spit on my knee, he'd rub toothpaste on it," said Gene Mauch. Doc also invented his world-famous Andy Lotshaw Body Rub, which was sold everywhere. If a person bought a Cubs team photograph pack, he or she would get a coupon for 10¢ off. What was in the magic potion? "Turpentine, lemon oil, olive oil, and some other things I ain't tellin'."

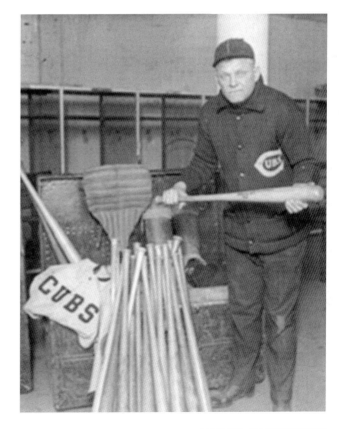

He had been quite a ballplayer himself until an injury stopped him. As a rookie in 1906, Lotshaw smacked 24 triples for Jacksonville—a Kitty League record that still stands more than 100 seasons later. His minor league averages included .329, .355, and .349—with power—and he carried around faded, yellowing clips to prove it. "The train was resting on a siding near Albuquerque, waiting for the new streamliner to whiz past," Howard Roberts wrote in 1938 for the *Chicago Daily News*. "As it zipped past the Cub Pullmans, Andy puffed out his chest. 'Reminds me of Lotshaw on the base paths,' he cracked."

Cy Block's lifetime major-league average is .302—all with the Cubs. In fact, as a rookie in 1942, he hit .364. But he only made it into 17 games over three seasons, because he was a third baseman when Stan Hack was there. "Block gained considerable attention in the 1942 spring camp by his noisy Brooklynese chatter," Mouse Munzel wrote in the *Chicago Sun* in 1946, when Block was back from the war. But Hack was still very much at third, so Block was forced to languish in the minors. He didn't languish quietly either, producing a .314 lifetime average and winning Sally (South Atlantic) League MVP honors in 1941 (.357 at Macon) and setting a Southern Association record with 50 doubles (.360 at Nashville) in 1947. When he finally retired back to Brooklyn after the 1950 season, he hit the ground running and went on to be the number-one Mutual Benefit insurance agent in the entire country. (Courtesy of Cy and Harriet Block.)

Mickey Owen was an all-star catcher four times, but he is famous for two things: his longtime baseball camp in Missouri and a single play in the 1941 World Series. His passed ball let the Yankees sneak back to win a game, a significant irony because that season he set a catching record for most errorless chances. The Mick took his wife out to Catalina with him, and son Charlie said, "Mother always had a twinkle in her eye when she talked about that place."

A COLORFUL CAST OF CHARACTERS

Bob Rush was the only pitcher besides Bob Feller who served 100-mile-an-hour fastballs back then, and he needed quite a windup to achieve that kind of velocity. Bob helped win the 1952 All-Star Game while a Cubbie and pitched in the 1958 World Series after Chicago traded him to Milwaukee. He is also one of the ballplayers on the famous Norman Rockwell *Saturday Evening Post* cover from 1948 showing some beleaguered Cubs in a losing dugout.

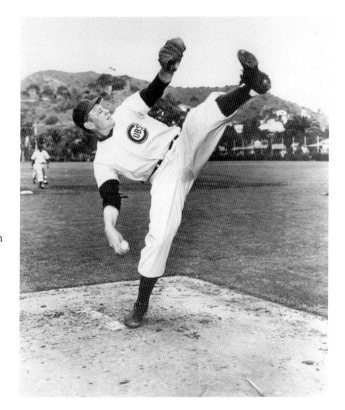

In 2003, Bob Rush returned to Catalina for the Cubs reunion. He told tales to the crowd about coming to the island a few weeks ahead of schedule. "I went out with my wife," he said, "I just wanted to get out early, because at the time I lived in Indiana and it was still winter! We threw, we did some running around the field—some light tossing, just to get the arm ready." But things went up a notch when the manager arrived. "When Frankie Frisch got there," Rush said, "we ran up the goat paths!"

JOHNNY KLIPPSTEIN

Johnny Klippstein, clearly standing on Catalina (rather than in Chicago) for his 1951 Bowman card, spent 18 years in the majors. A starter who switched to the bullpen, he won 101 games and led the American League in saves in 1960. Johnny pitched well in the 1959 World Series (for the Dodgers) and the 1965 Fall Classic (for the Twins). As a rookie on Catalina, he sought out veteran Johnny Vander Meer for advice. "We'd have some great chats," Klippstein said, "We'd talk mostly about how to handle it, how to approach the game, rather than specific pitches." It helped him overcome his early nickname, "The Wild Man of Borneo," to develop big-league control. After retiring, he stayed active as president of the Old-Timers' Baseball Association of Chicago (a post now held by Andy Pafko).

Bill Serena played third base for the Cubs from 1949 to 1954 after hitting 57 homers (and .374 average) for Lubbock in 1947. He and Randy Jackson used to tease each other about how far back they would play Hank Sauer in spring games on the island—fearing for their safety. On St. Patrick's Day in 1950, Serena won a ham during a dinnertime drawing; he gave it to local teen Frank Saldaña (who went on to hit .667 for Avalon High in 1953, a school record that still stands). Frank took the ham home, "But my parents didn't believe him," big brother Lolo the barber says. "They thought he stole it! They told him to take it back. But he finally convinced them how he'd gotten it."

"We were so busy climbing mountains," Ed Chandler recalls from his 1950 and 1951 Catalina tours, "there wasn't time for much golf." But that was nothing compared to Chandler's springtime experience on another island trip, when the 1948 Brooklyn Dodgers trained in the Dominican Republic. In Venezuela for an exhibition game, Eddie was arrested in the sixth inning and paraded across the field, handcuffed while still in his uniform. Why? He couldn't play due to a contract goof, and the local promoter (who apparently had some friends in the police force) took offense. Fortunately for Ed, he was soon sprung and able to return to the normal rigors of training camp.

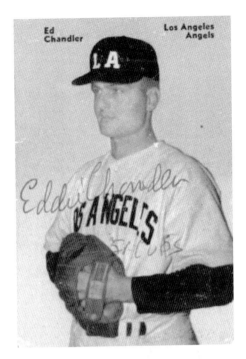

Manager Frankie Frisch lines up his players for some sprints following a morning of mountain climbs. Frisch was a Hall-of-Fame player who had achieved success as a Cardinals manager in the 1930s, but he lost his steam by his Cubs tenure (last place, second to last, and last again from 1949 to 1951). "What finally got Frisch fired," Cavarretta recalls, "was he was reading a novel in the dugout, during a game." After a series of Cub strikeouts, "Frisch starts cussin' and he throws the book right onto the field—almost hit the third-base coach with it!"

Lee Anthony played, managed, coached, and scouted in professional baseball for six decades. Unfortunately, he never officially made a major-league roster as a player, although he had some Cubs tryouts and went to the Giants camp a few years later. In the minors, he pitched a no-hitter as a teenager (but lost because of poor fielding behind him) and ended up with 161 wins, including a few glory years with the Hollywood Stars and Los Angeles Angels in the old Pacific Coast League. And he had an unusual hobby, "I crochet a rug for the house when I was out there in 1948," he recalls, "some of the guys didn't let me forget that when they heard about it."

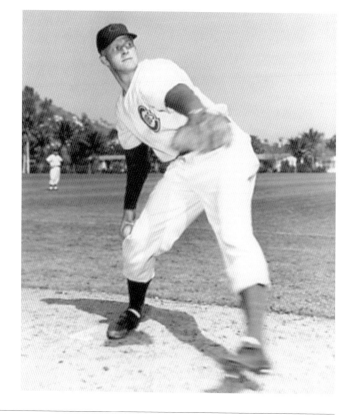

Warren Hacker pitched in the majors for 12 years, 9 with Chicago. While in the PCL, he pitched a no-hitter for the Angels; as a Cub, he went 15-9 in 1952. "He was a three-quarter sidearm pitcher," rookie pitcher Eddie Kowalski recalled. "Nobody wanted to face Warren."

A COLORFUL CAST OF CHARACTERS

In just 15 starts for the 1952 Cubs, Bob Kelly twirled two shutouts. In all, he pitched for three major-league teams. "The only one who ever really taught me anything about pitching was Bob Kelly," Turk Lown recalled. "Bob showed me how to throw a slider. I was fortunate; it moved. A lot of guys can throw hard, but you need some movement on the ball."

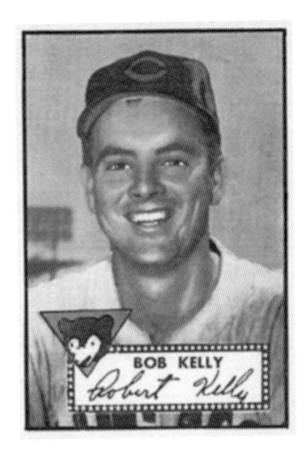

Bob Scheffing hit .300 as the Cubs starting catcher in 1948 after leading the league in pinch hits in 1946. His career spanned from 1941 to 1951, with a few years missing for the war. His tenure with the Cubs coincided with a lot of losing seasons, so he often assumed the "waiting after an opponent's home run" pose, shown here. Scheffing later managed the Cubs (1957–1959) and Tigers (1961–1963). His Detroit team won 101 games in 1961, but that was a rather amazing season for the Yankees, and the Tigers finished second. Even so, he was still named AL Manager of the Year. He later moved to the front office, and as Mets general manager he won a pennant in 1973.

"My biggest weakness was the pitched ball," Paul Schramka admits. But at the time, the Cubs had high hopes for their Catalina rookie. "Schramka is the only ballplayer around who swings like Ted Williams," the long-gone Cubs director of player personnel noted. Unfortunately, Paul's big-league career was called on account of rain. Hank Sauer hurt his finger just before the opener, and "I got to replace Sauer," Schramka said. "The opening series, the City Series, got rained out. Then, we went to Cincinnati, and it rained. When it finally stopped raining, Hank was able to play again." Paul's lifetime record—two games, zero at-bats.

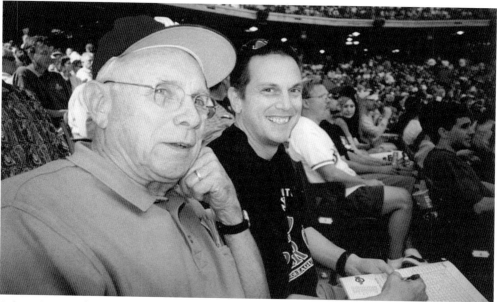

Schramka had transferred from Notre Dame to the University of San Francisco, where he played baseball and basketball. "At that time, there were not a lot of college kids in baseball. One of the pitchers said, 'When you're in the outfield, when you have to call, 'got it, I got it,' since you're a college boy, maybe you better yell, 'I have it, I have it!' " He got his draft notice, but after he came back the organization seemed to lose him in their farm system. Undaunted, Schramka used his intelligence to his advantage. He commented, "I went into the funeral business with my dad and my two brothers. My dad said, 'Business is bad—nobody's even sick!' " Schramka ran the company for years and now heads the Old Time Ballplayers' Association of Wisconsin—3,000 members strong. Seen here at a Brewers game in his hometown of Milwaukee, Paul regales the author with tales (some true, some expanded) about his Catalina days. (Courtesy of Ruth Schramka.)

Paul returned to the island in 2003 for the Cubs reunion, taking time to do an interview for the television cameras. Here Jerry Hara of Diamond Production Group in San Diego directs Paul into place, as Lou Joseph keeps an eye on the talent. Paul's primary claim to fame is that he wore No. 14 just before Ernie Banks came along, in the same season. Thus, in those hand-me-down days, they probably wore the same jerseys. When the Cubs retired the number, Schramka sent Banks a telegram, reading, "I left all the base hits in the jersey for you."

After playing outfield for six seasons, Hal Jeffcoat changed his mind—and pitched for six more. He didn't set any records on either side but got the job done well enough to last from 1948 through 1959. While on Catalina (his 1951 Bowman card, like a few others, clearly portrays the island and not Chicago), Charlie Grimm nicknamed the prankster "Hotfoot Hal." And he had other talents, too. "Wrigley had a rodeo on his ranch," Carmen Mauro recalls, "they selected Hal and me to chase some pigs inside a ring—I guess they wanted people who could run and dive. They let 'em loose, all covered with oil and grease and the dirt flying—but we did it. We tackled 'em. Those were the ones that were gonna be roasted!"

GENE MAUCH

"Gene Mauch was one of those feisty players," Bob Rush recalled, "who wasn't afraid to get his uniform dirty. He had that desire—he was into the game all the way." Mauch's nine-season major-league playing career (two with the Cubs) was adequate, but it was primarily a prelude to his calling as a major-league manager. Skip skippered the Phillies, Expos, Twins, and Angels for 26 years—winning 1,902 ballgames. He retired after the 1987 season, one of the last Catalina Cubs to still be wearing a major-league uniform.

One of the few remaining Cubs from their final 1945 World Series adventure, Andy Pafko was a true star in the 1940s and 1950s. He hit .300 four times during his 17 years in the Show, with back-to-back 30-homer seasons. He played in five All-Star games and four World Series for all three of his teams (Dodgers and Braves, too). Generally the pillar of consistency, Handy Andy managed to get into a little trouble on Catalina in 1950. He and Carl Sawatski "got their hands full of poison oak while clambering around the island," Al Wolf wrote in the *Los Angeles Times*. "They'll have to sit out the first few days of official toil." But, Wolf noted, "the poison oak didn't hamper their reclining ability." Andy is still active as can be serving as president of the Old-Timers' Baseball Association of Chicago.

ANDY PAFKO

A COLORFUL CAST OF CHARACTERS

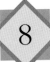

ARIZONA AND
AFTERWARDS

In 1952, the Cubs moved their spring site to Arizona, which offered different diversions. "In Mesa," Randy Jackson recalls, "there was a dog track close by. When we were there, they'd name dogs after us. I bet on Randy Jackson a couple of times, but I'd always lose." As Catalina camp faded into memory, several of the gang stayed in the game, and a few years back some of them returned to the island for a reunion. Like the old days, the locals turned out en masse—more than 250 descended on the country club one night. In 1952, suburban Phoenix was much easier to reach, with more major-league teams training nearby for exhibition games. These days, the Cubs play at Hohokam Park, also known as Dwight Patterson Field. (Courtesy the City of Mesa.)

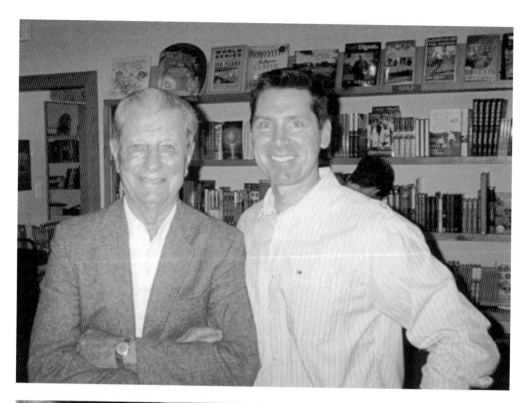

Tim Sheridan (right), seen here with Catalina Cub Andy Pafko, is the stadium announcer for spring games. Tim has created a web site devoted to Cubs' spring training: www.boysofspring.com.

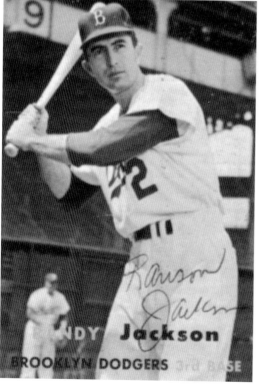

Individual Cubs moved on as well. Randy Jackson went east, where he hit the final Brooklyn Dodger home run at Ebbets Field in 1957.

Calvin Coolidge Julius Caesar Tuskahoma McLish actually had a nickname: Buster. Cal pitched in the Show for 15 seasons after his first trek to Catalina, finally wrapping up with the Phils in 1964—long after he had broken in with the Dodgers in 1944. Along the way, he was an all-star in 1959 and set a big-league record with 16 straight road wins. He coached in the majors until 1982 and has continued scouting into the new century (seven decades in major-league baseball), working alongside other long-lasting Catalina Cubs Gene Mauch and Hub Kittle more than 50 years after the last spring on the island.

CAL McLISH pitcher

Johnny Klippstein and Smoky Burgess were the final two Catalina Cubs playing in the majors. Both lasted until 1967, sixteen seasons after the 1951 departure. Klippstein evolved from a fastball pitcher to a "stuff" pitcher over time, as a lot of long-lasting mound men do. John's switch wasn't soon enough for Wayne Terwilligerh. "He hit me in the head once," Twig said, "I had a helmet on; it cracked the helmet. It felt like I wasn't wearing a helmet, like it cracked my head!"

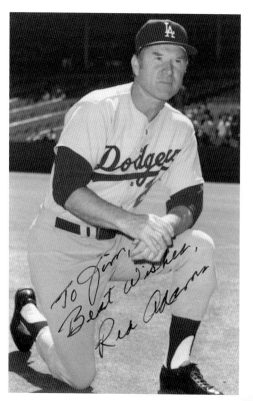

Red Adams had an ultra-brief major-league career (one game with the 1946 Cubs) and a great minor-league career (193 wins over 19 seasons), but all that was a prelude to his life's work when he became one of the most respected pitching coaches of all time. As part of the Alston and Lasorda Dodger staffs from 1969 to 1980, Red developed young talent (like Fernando Valenzuela and Don Sutton) and helped veterans (like Tommy John and Claude Osteen) hone their craft. When Sutton was inducted into the Hall of Fame, he said, "Red Adams is the standard by which every pitching coach should be measured. Without him, I wouldn't be standing in Cooperstown today."

ProCards®

GUS CHERRY
President & Owner
Omaha Royals

Irving "Gus" Cherry actually stepped up from being a Catalina Cubs rookie to owning a team. Casey Stengel once called Cherry's curve "the best he ever saw," but arm trouble ended a career that looked promising in 1937. No problem; Gus went on to design skyscrapers before buying the Omaha Royals. In 1980, at the tender age of 63, he finally appeared on his rookie card.

Terwilliger is the final Catalina Cub to still appear in uniform. Twig managed the Fort Worth Cats to a league championship in 2005 and as of 2009 is still coaching there—at the tender age of 84. His seven-decade career began in the late 1940s; he played in the Show for nine seasons, and he's been coaching or managing in professional baseball ever since.

There is no head coaching in baseball—but don't tell that to P. K. Wrigley. From 1961 to 1965, the hapless Cubs used their infamous "College of Coaches" approach to remain in the cellar. Mercifully, it came to an end in 1966, when Leo Durocher took over as manager.

COACHES

PRESTON GOMEZ

GRADY HATTON

HUB KITTLE

JIM OWENS

LEO DUROCHER
HOUSTON ASTROS — MANAGER

In 1973, during his fifth (of eventually eight) decades in professional baseball, Hub Kittle finally appeared on his rookie card—Hub's first, Leo Durocher's last. "The Cubs hired me for 50 bucks a month in 1936," Hub recalled about 70 years later. He tossed two no-hitters for the semi-pro Catalina Cubs. He remembers, "We were working for the Santa Catalina Island Company. They hired us to play ball, but since we worked for Mr. Wrigley's company we did other things too. They had us pick up the garbage, empty the cans by the ballpark—it was part of our work." He also borrowed a rowboat and caught sheepshead for a local Greek restaurant in exchange for a meal ticket. Hub also won dancing contests and sang at the casino, snuck out after the 11 p.m. bed check to "meet the gals by the 18th tee," talked baseball with future movie stars (like Marilyn Monroe), tossed slowballs to a future president (radioman Dutch Reagan), and partied hard. "The last night we were on the island," Lefty Carnett recalls, "we had a hot time. Hub, Goo-Goo Galan, and Billy Herman made a lot of noise—we even rolled a few 55-gallon drums down the hill. Around three in the morning, the police stopped us and told us to go back to the hotel."

ARIZONA AND AFTERWARDS

Kittle's on-the-field accomplishments were enduring as Hub pitched professionally in six different decades. He won 144 games during his "initial" 1937–1958 minor-league career, including a 20-win campaign in 1939 and seasons with classic teams like the San Francisco Seals and Oakland Oaks in the old Pacific Coast League. He transitioned to player/coach, then player/manager (in 1948), and finally manager—20 years at that, winning more than 1,000 games and several championships into the 1970s. In the meantime, Hub also moved upstairs and was named Minor League Executive of the Year by The Sporting News. In the off-seasons, he played, coached, and managed in the Winter Leagues of Mexico and the Caribbean. (Whitey Herzog, arriving in the Dominican Republic as a player for the first time, was awaiting his ride at the airport. Kittle appeared, galloping on a horse, "Are you Herzog? Get on!") In 1969, at age 52, Hub pitched two innings for Savannah. In 1973, Durocher called him in as the ninth-inning closer of an exhibition game between the Houston Astros and Detroit Tigers. He shut down the side, at age 56, to earn the save. And in 1980—63 years young—he pitched a scoreless inning for Springfield. "I got out there, and the sucker bunts!" Kittle recalled, "so on the next pitch, I knocked him down." "His legacy," John Garrity wrote in Sports Illustrated, "is that of the man who cussed and roared and squeezed more joy out of baseball than anybody before or since." Hub finally got a World Series ring in 1982, as Herzog's pitching coach. (One of his pupils, Dave LaPoint, says he once found Kittle in the hotel lobby at 3 a.m. trying to teach a bellhop how to throw the forkball.) Yet he wasn't done yet, staying on as a Mariners pitching instructor until his death in 2004. Along the way, he was inducted into the Washington State Hall of Fame, and the New Jersey Cardinals retired his number. At his insistence, his tombstone states, simply, "He loved the game."

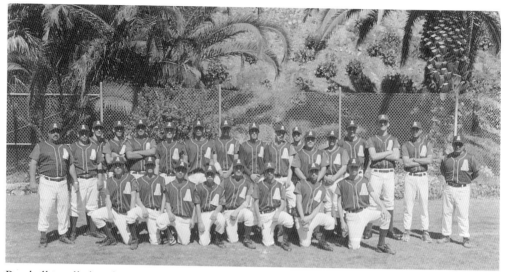

Baseball is still played on Catalina. This is the 2003 Avalon High School Lancers team, who won the divisional championship in 2001. (Courtesy of Avalon High School.)

PBS dispatched a crew to do a *California's Gold* episode about the Cubs on Catalina in 2004. The DVD is available at www.calgold.com.

The Cubs have done just about everything to break "the Curse" that's kept them from the World Championship for more than 100 years. In 2003, they invited singer Shania Twain to toss the first pitch. (That didn't help either.) The Cubs have actually continued to play on islands after vacating Catalina—and during the regular season no less. While Major League Baseball was contemplating what to do with the Expos in 2003 and 2004, the team played some of their "home" games at Hiram Bithorn Stadium in Puerto Rico. (Bithorn, as it happens, was a Catalina Cub in the 1940s.)

As time marches, islands have given way to continents and Cub Nation has expanded to Cub Globe: Al Epperly's daughter, Sharon Epperly Vancil, received this photograph from a family friend in Iraq. Even over there, Cub fans know *we'll get 'em next year.*

Discover Thousands of Local History Books Featuring Millions of Vintage Images

Arcadia Publishing, the leading local history publisher in the United States, is committed to making history accessible and meaningful through publishing books that celebrate and preserve the heritage of America's people and places.

Find more books like this at
www.arcadiapublishing.com

Search for your hometown history, your old stomping grounds, and even your favorite sports team.